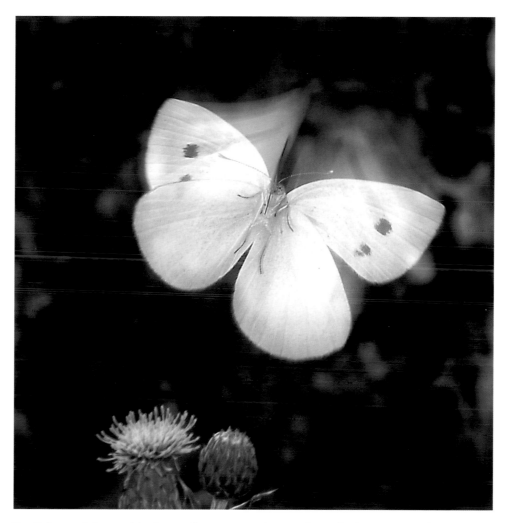

For John and Gina—like butterflies, you made people smile during your short season.

# FLYING FLOWERS

## The Beauty of the Butterfly

RICK SAMMON

welcome
BOOKS

NEW YORK & SAN FRANCISCO

*Butterflies . . . flowers that fly and all but sing.* —ROBERT FROST

4

How can a crawling sack of green goo with stubby legs and poor eyesight transform itself during a nap into a creature with delicate, scaled wings and superior vision—a creature that can fly swiftly and effortlessly through the air, navigate great distances, deter predators with camouflage techniques, find a mate, weather a storm and even freezing temperatures, and reproduce—all within a brief lifetime of weeks or months?

The answer to that question is a mystery, one that has intrigued humankind for centuries. Interest in the butterfly's enigmatic existence can be found in ancient Aztec, Chinese, Egyptian, European, Hopi, and Mayan civilizations, among many others. Still commonly celebrated and appreciated in modern cultures, they are exquisite symbols of transformation—reminders that life is a process of constant evolution, and that, as the Buddhists say, "Change is good."

My fascination with butterflies and moths began during a 2003 trip to Butterfly World in Coconut Creek, Florida—which is home to up to 4,000 butterflies at a time. While photographing Butterfly World's flying flowers, as they are often called, I met Ron Boender, a butterfly expert and founder of the facility, and Alan Chin Lee, the resident lepidopterist ("scaled-wing expert" in lay person's terms). Alan, who became my science advisor, witnessed my early attempts to photograph the elusive creatures and quickly offered to help me locate good shots. He soon pointed out two Clipper butterflies mating—a beautifully lit scene in which the pair seemed to have merged in color, texture, and pattern, becoming a single being for that fleeting moment. It was that sight, and viewing the captured image on my camera's LCD monitor moments later, that immediately convinced me to do a book on flying flowers so that I could share what I was seeing (page 24). Many have photographed dead butterflies, but I wanted to capture live butterflies in their natural habitats with an intimacy that would reveal their miraculous nature.

Over the next year, I made five trips to Butterfly World and one visit to the Key West Butterfly Conservatory. Each time, I returned to my home in Croton-on-Hudson, New York with a growing portfolio of species. My wife, Susan, soon fell in love with my subjects, and began planting specific bushes in our backyard to attract Monarchs, Tiger Swallowtails, Viceroys, Gulf Fritillary, Orange-Barred Sulphurs, and Mourning Cloaks. My backyard quickly became a photo studio, and our kitchen a breeding ground, where I set up mini-photo studios for caterpillars in which to feed, transform into chrysalises, hatch and then fly off into our garden.

My butterfly exploits continued. In January 2004, I ventured off with Alan and two of the world's top butterfly experts, Dr. Tom Emmel and Dr. Gary Ross, to Sierra Chinqua in Michoacan, Mexico to photograph a colony of Monarchs during their annual migration. It was an arduous adventure: a five-hour car ride from Mexico City, followed by a one-hour drive on winding roads, then another hour on horseback and finally an hour's walk to the colony—all in near freezing temperatures and on snow covered ground. It's hard to describe the feeling of witnessing such a massive gathering of these magnificent animals. As the saying goes, "Even in silence, beauty is eloquent beyond the power of words."

So this is a book about living butterflies, and how their beauty and fleeting lives can teach us something about our own spirit and relationship with nature.

—R.S., Croton-on-Hudson, New York, April 2004

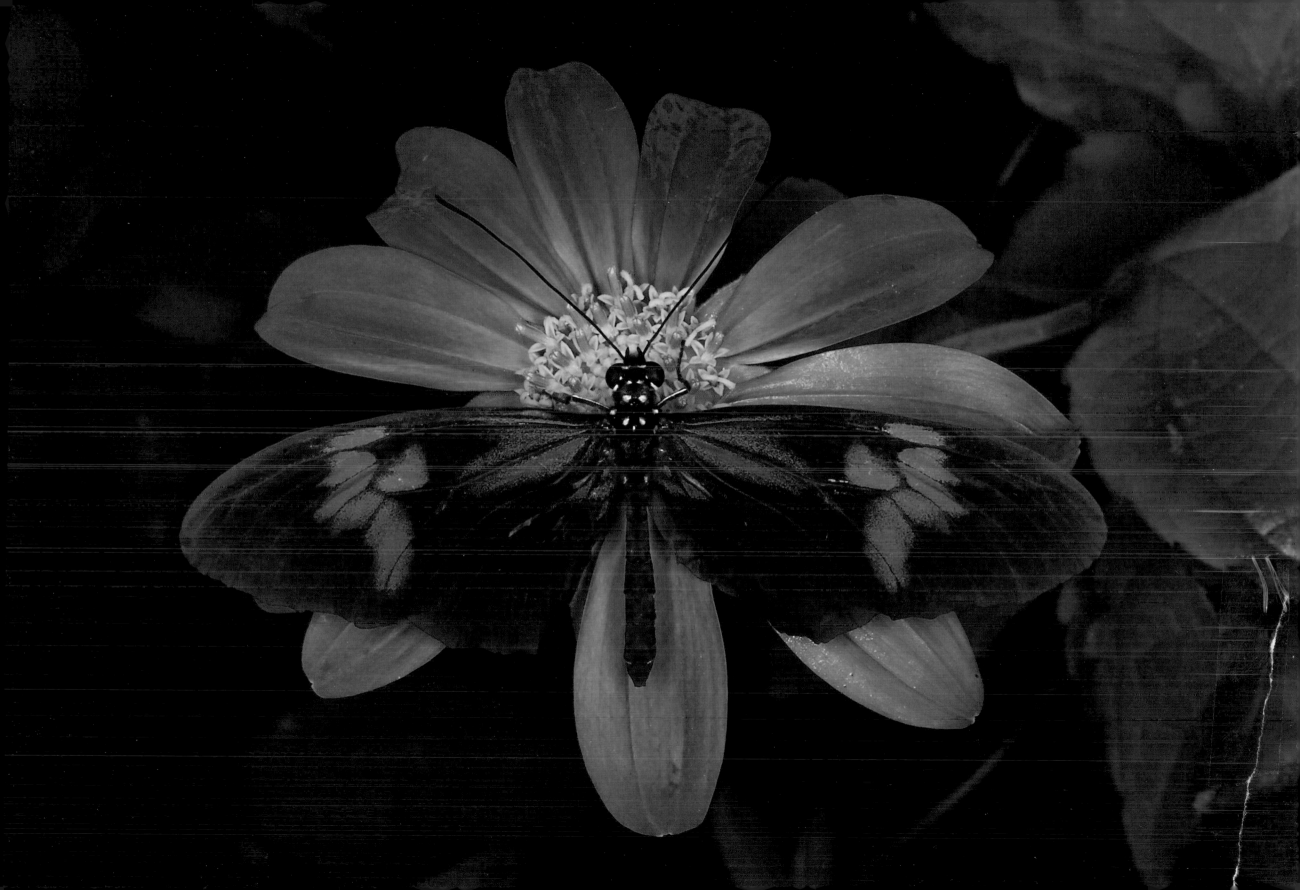

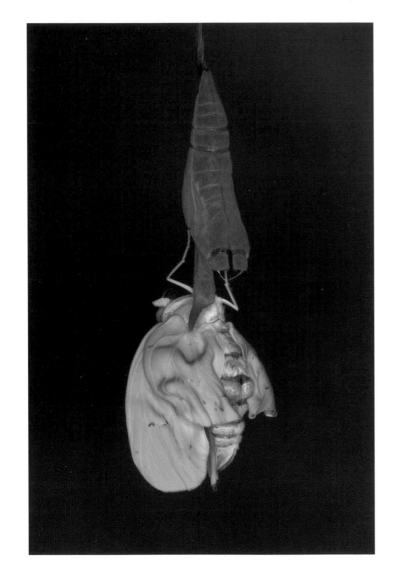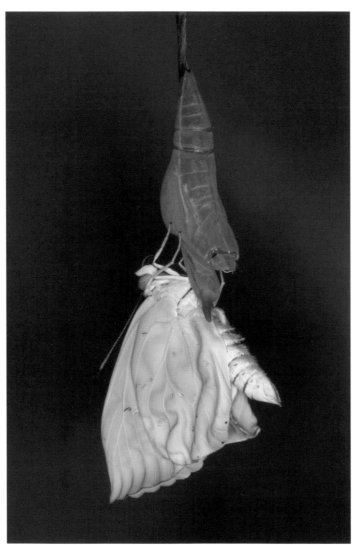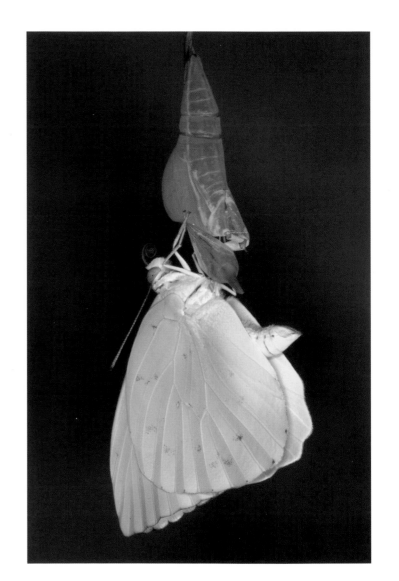

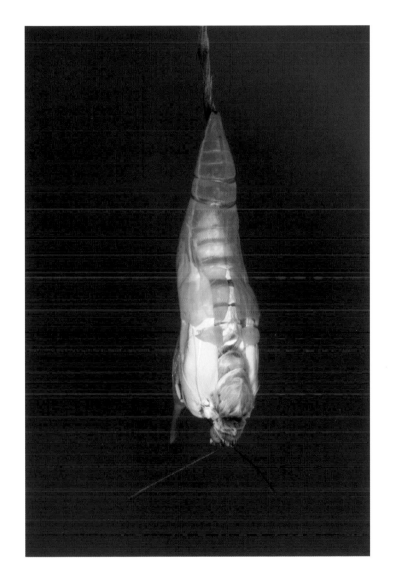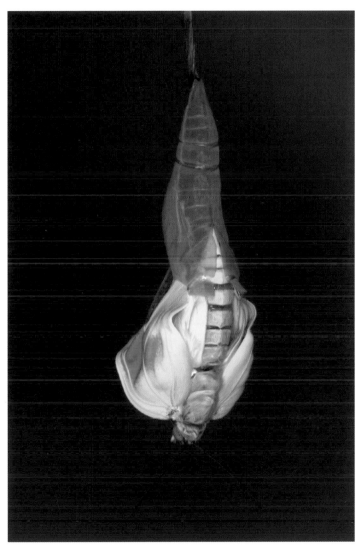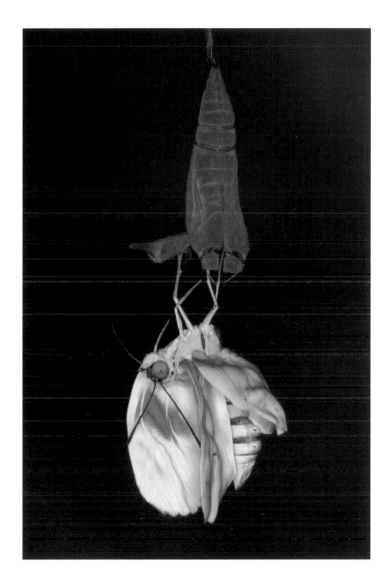

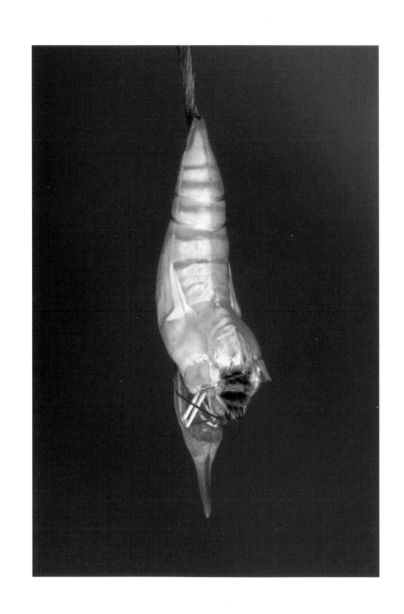

What the caterpillar calls the end of the world, the Master calls a butterfly.

—Richard Bach, author

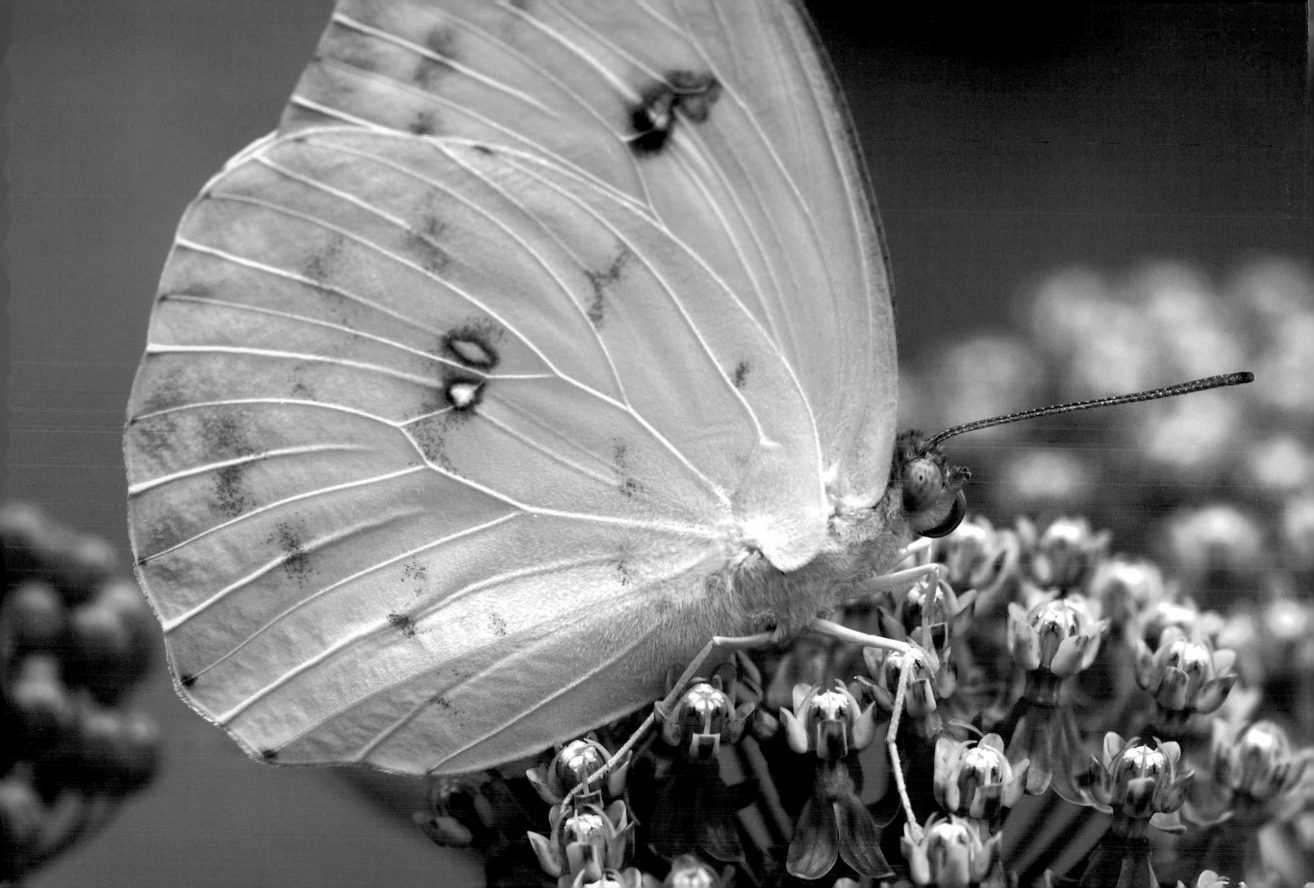

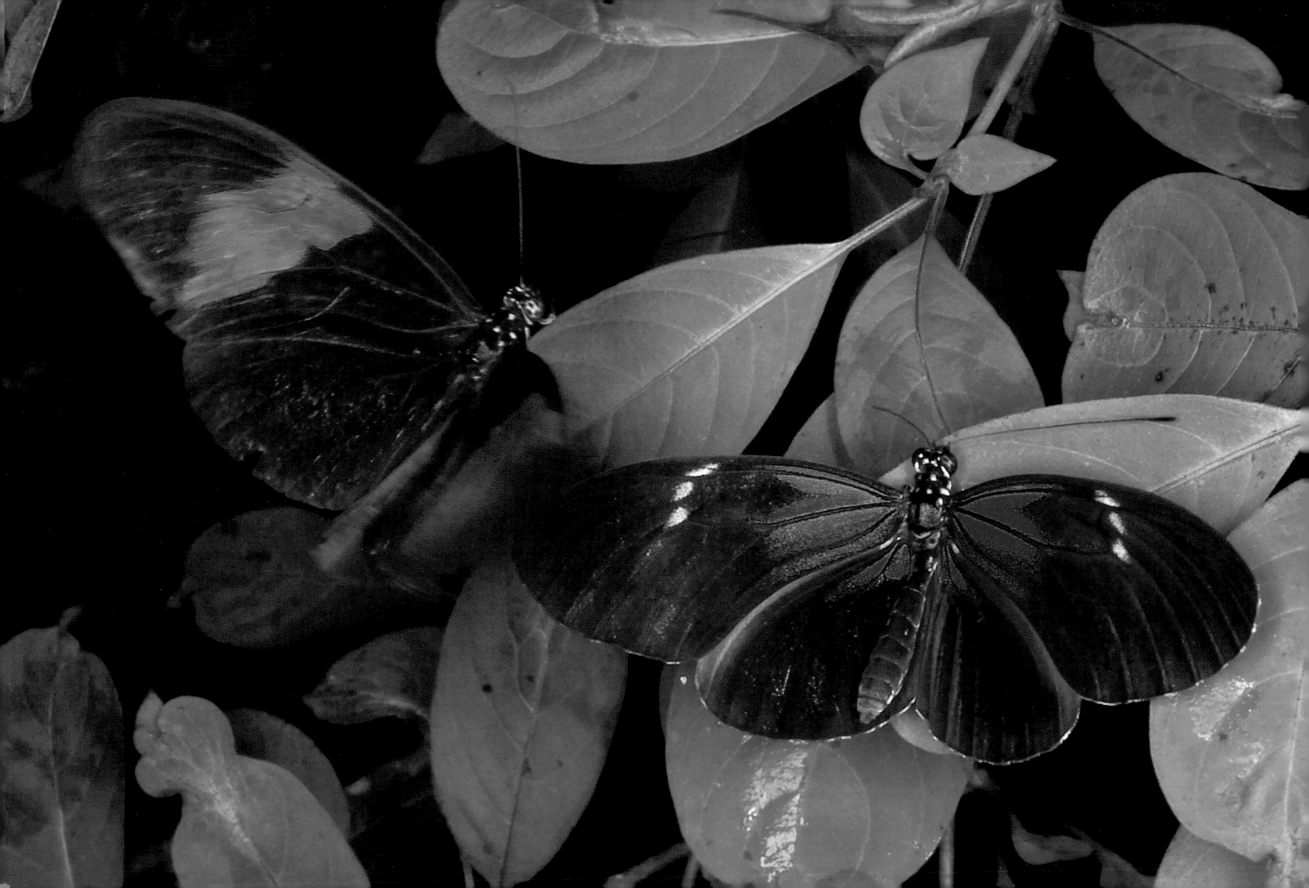

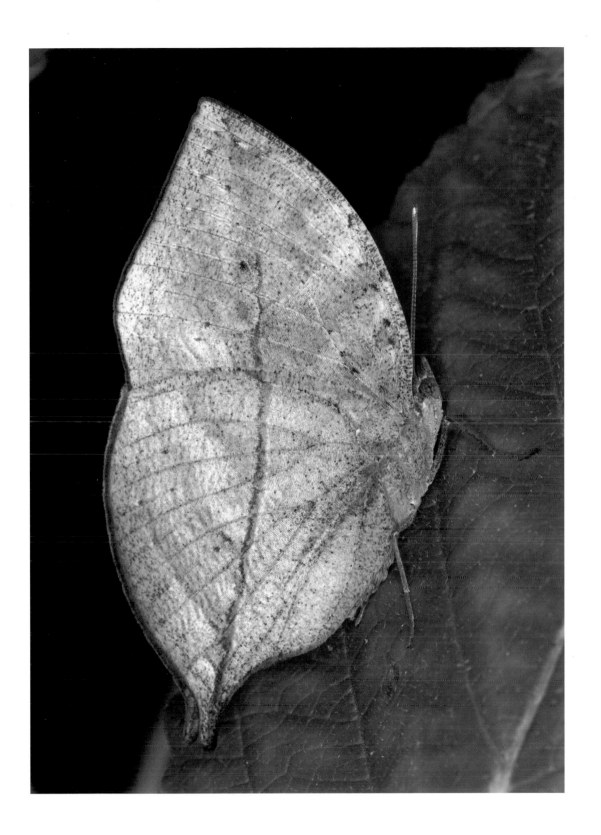

[opposite]
*Heliconius melpomene*
THE POSTMAN
RANGE: Central America
to southern Brazil

[left]
*Kallima paralekta*
INDIAN LEAF
RANGE: India to Sundaland

12 [right]
*Speyeria cybele*
GREAT SPANGLED FRITILLARY
RANGE: Canada and the United States

[opposite]
*Parthenos sylvia*
CLIPPER
RANGE: India to Sri Lanka through
Malaysia to Papua New Guinea

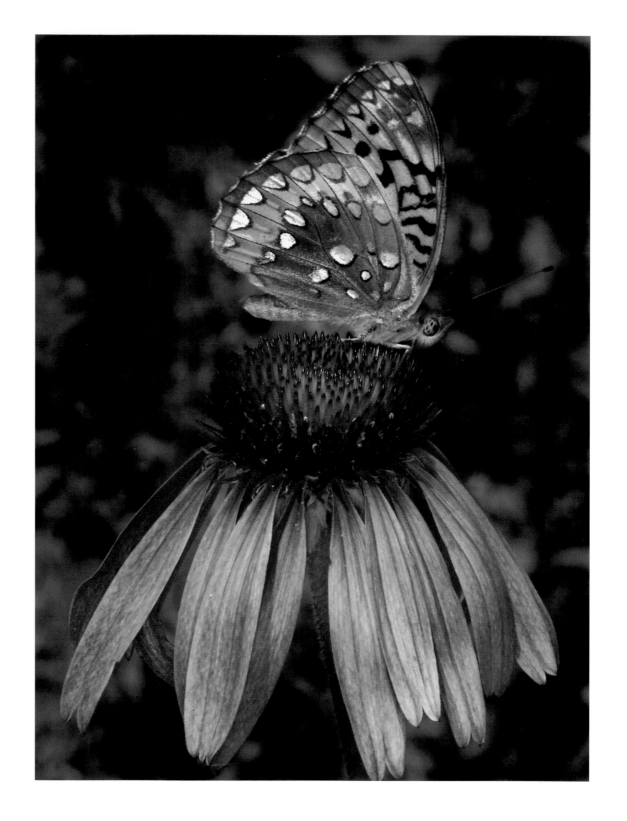

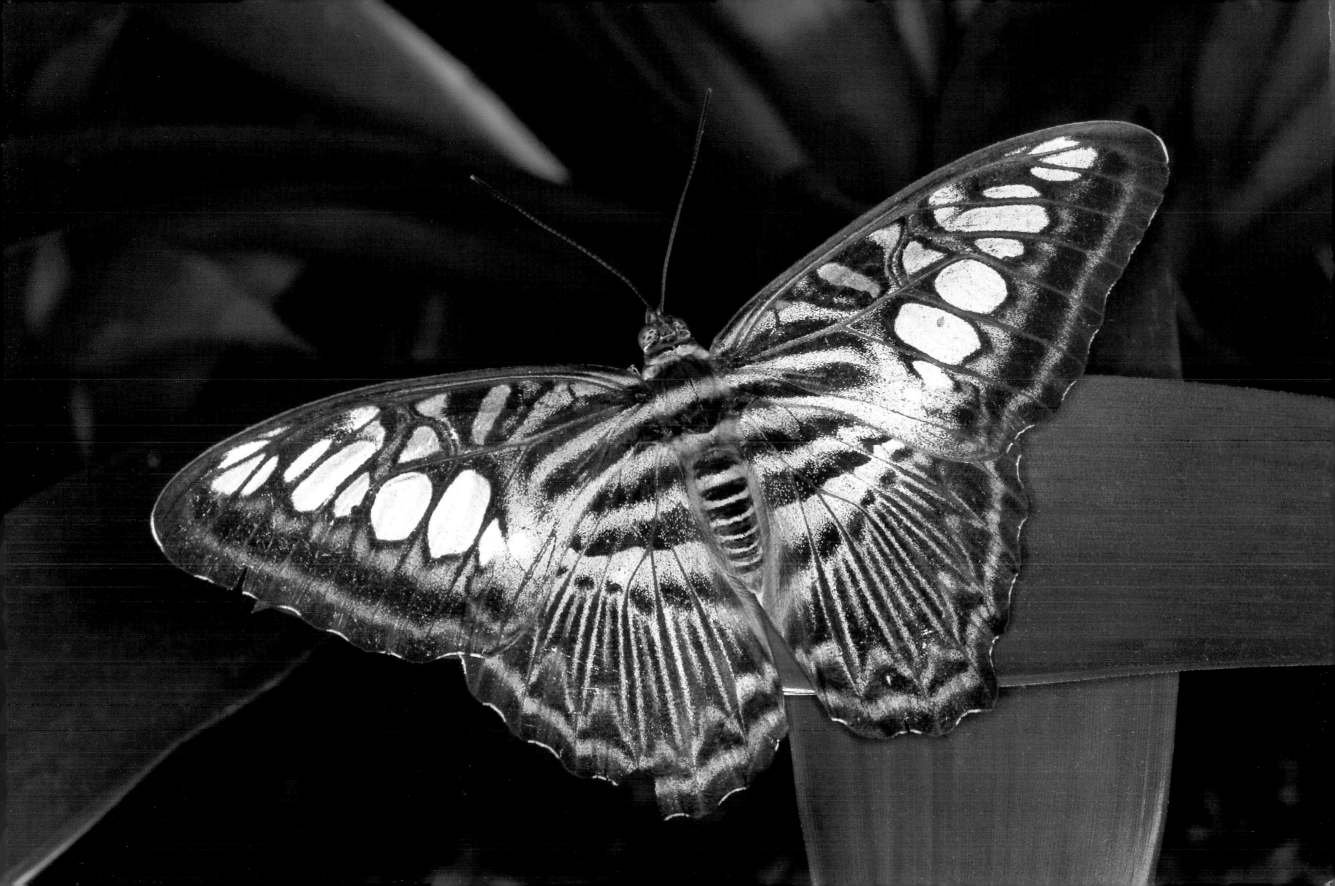

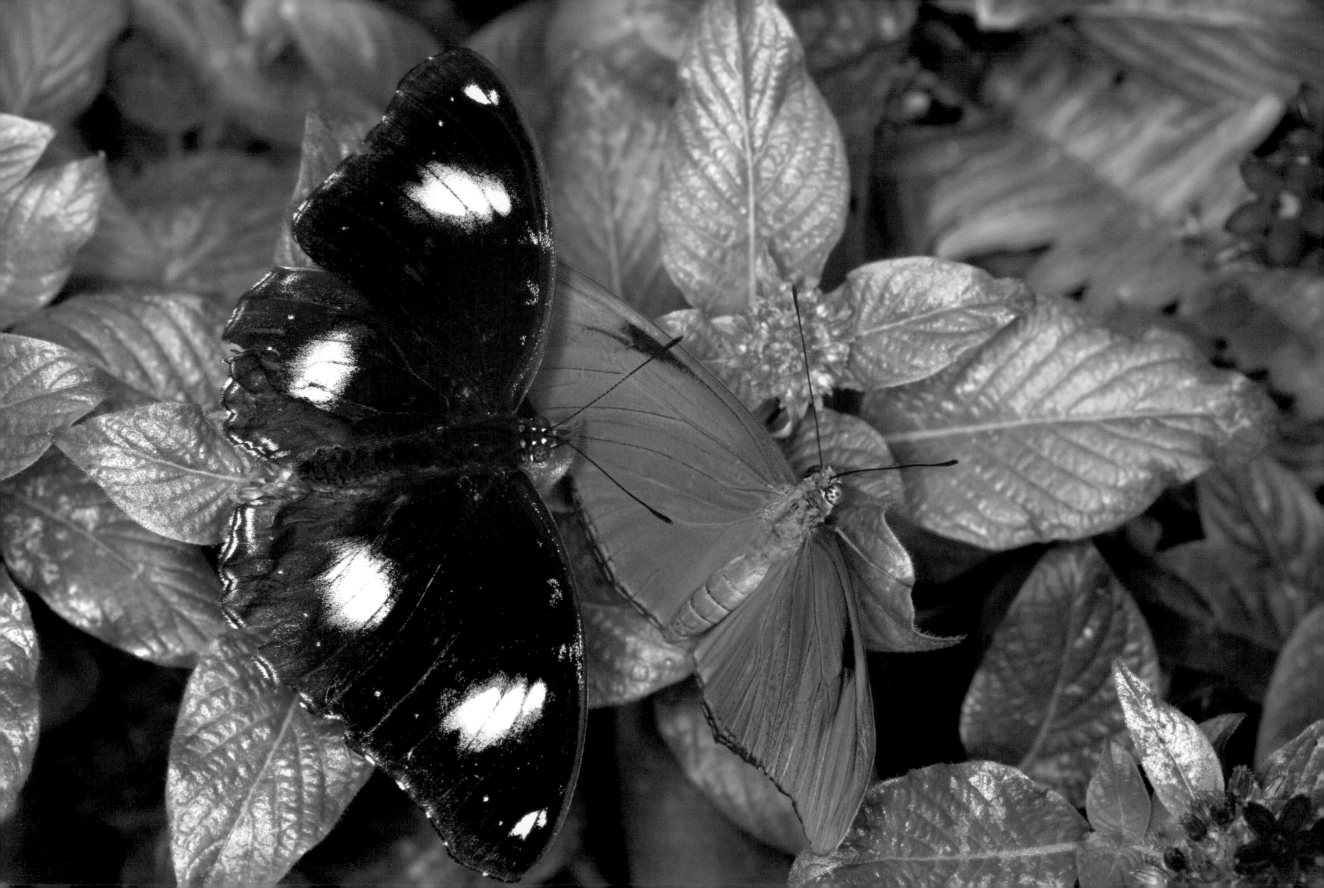

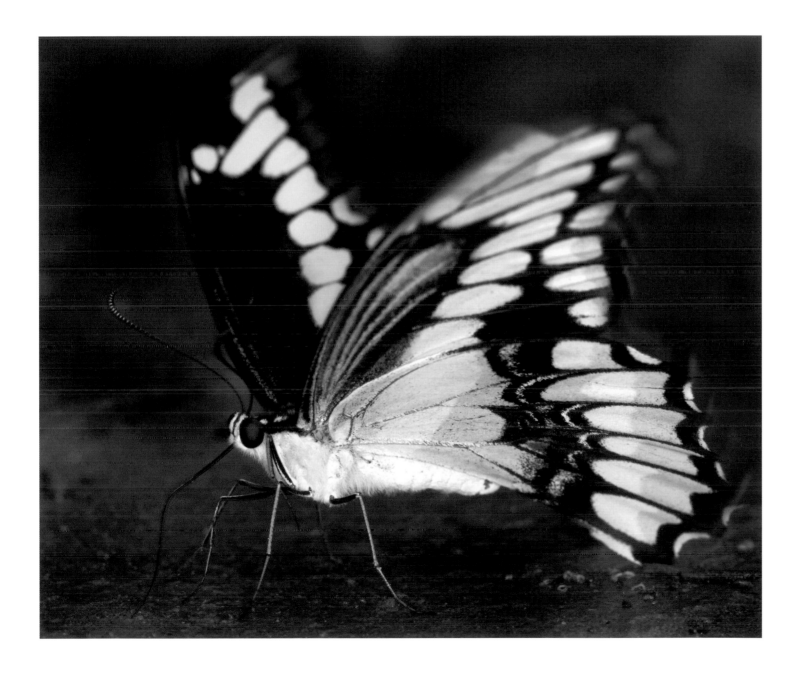

[opposite]
*Hypolimnas bolina* (left)
GREAT EGG-FLY
RANGE: India to Taiwan, Australia,
Indonesia, the Philippines,
and Malaysia

*Dryas iulia* (right)
JULIA
RANGE: Central and South America,
Texas and Florida in the United States

[left]
*Papilio cresphontes*
GIANT SWALLOWTAIL
RANGE: Canada to Panama,
and Colombia

16

[right]
*Heliconius melpomene*
PIANO KEY
RANGE: This particular butterfly is bred with patterns that vary from its wild counterparts for display at Butterfly World, Florida

[opposite]
*Papilio glaucus*
TIGER SWALLOWTAIL
RANGE: Canada, the United States, and throughout the Gulf of Mexico

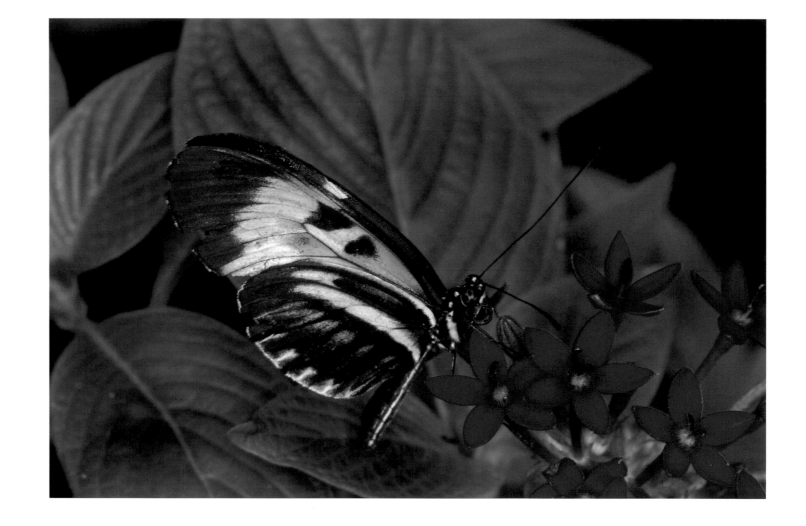

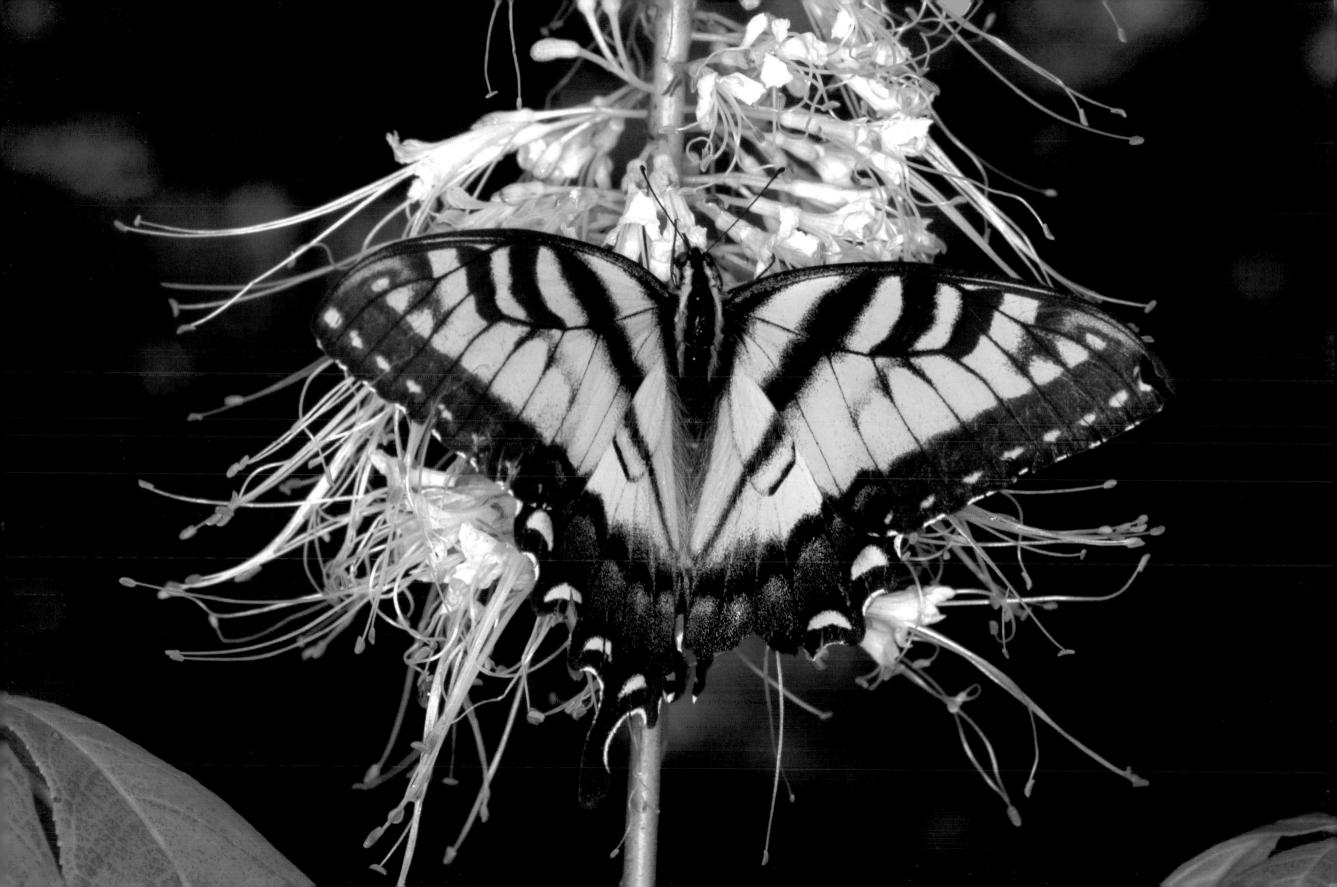

18 *Idea leuconoe*
LARGE TREE NYMPH
RANGE: Thailand to Malaysia,
Philippines, and Taiwan

Their spirits beat upon mine
Like the wings of a thousand butterflies.

—Edgar Lee Masters, poet

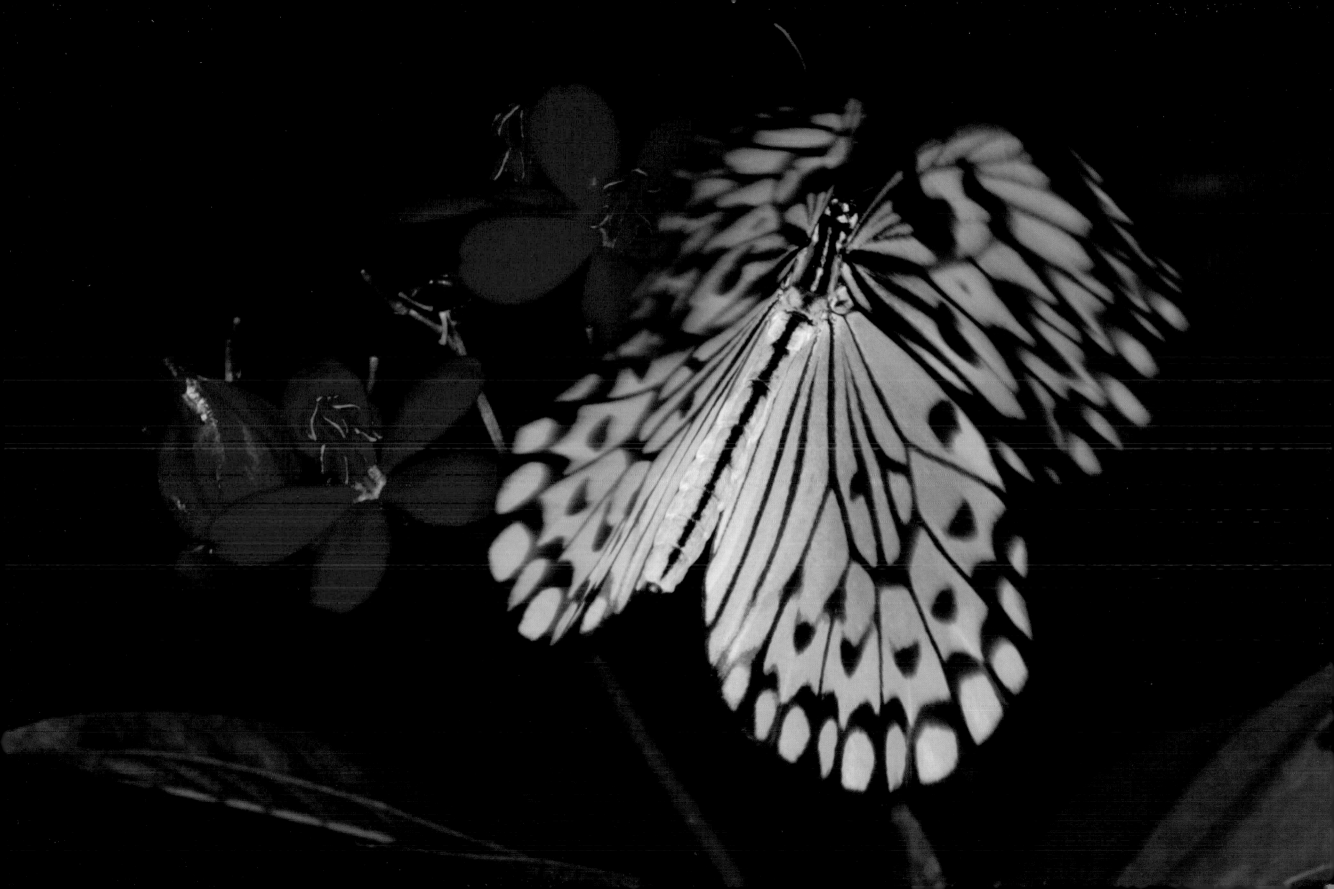

20     *Anartia jartophae*
WHITE PEACOCK
RANGE: Central and South America,
southern Texas and Florida in the
United States, and the West Indies

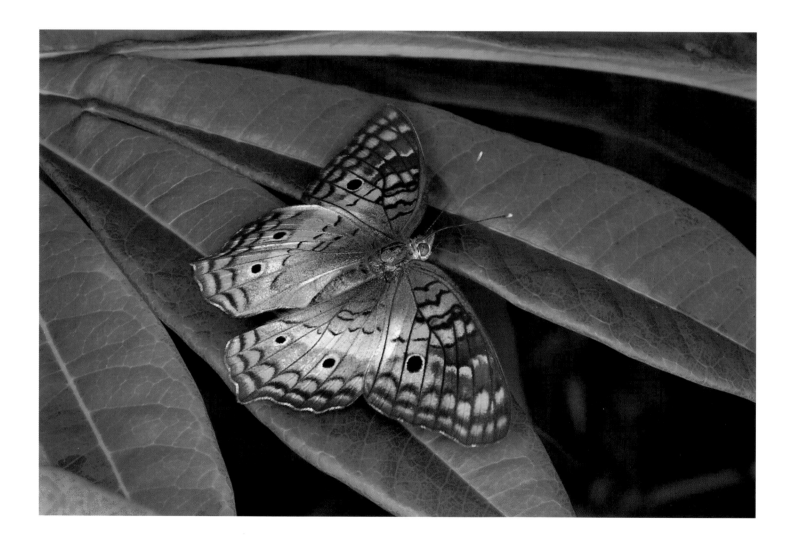

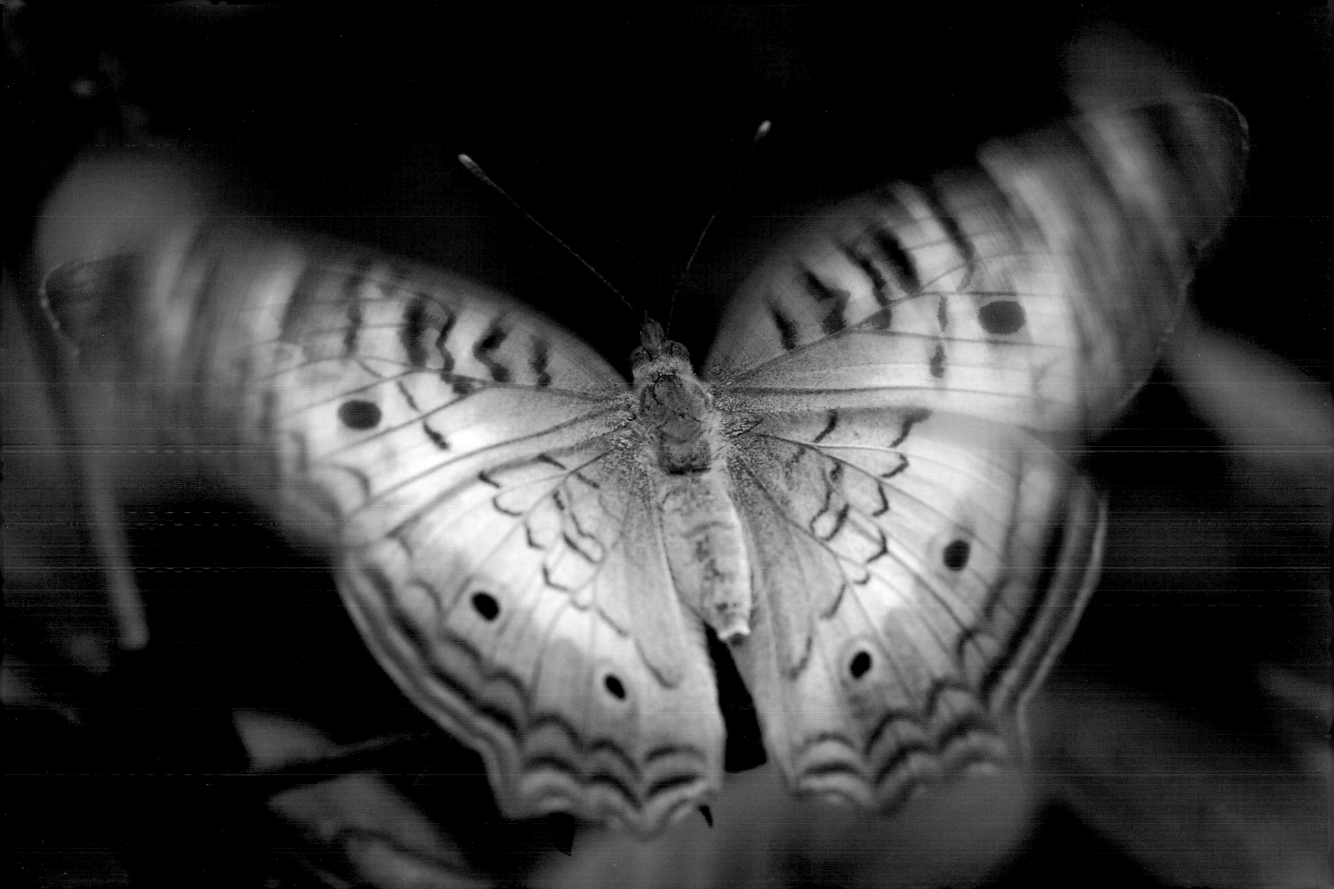

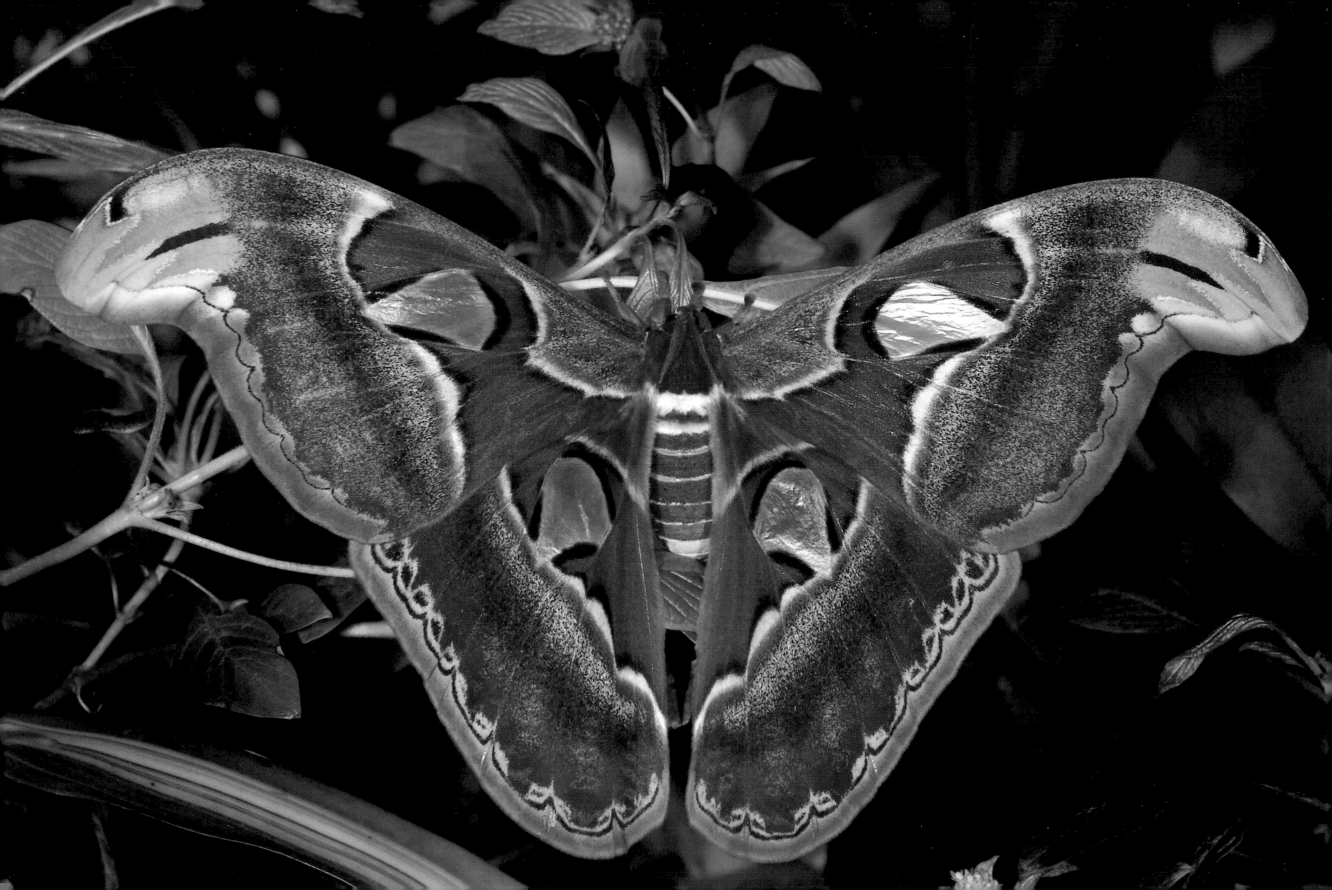

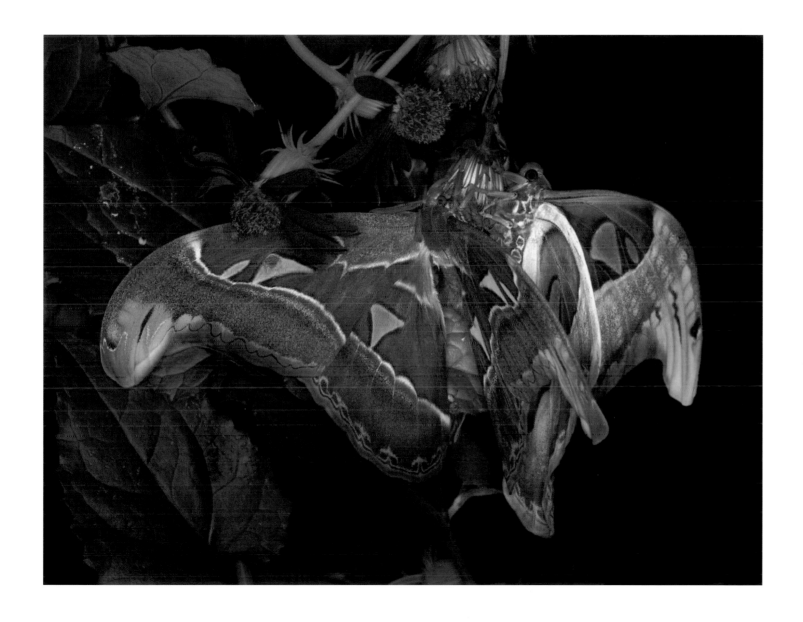

*Attacus atlas*
ATLAS MOTH
RANGE: India, Sri Lanka to China, Malaysia, and Indonesia

23

24

[right]
*Parthenos sylvia*
CLIPPER
RANGE: India to Sri Lanka through
Malaysia to Papua New Guinea

[opposite]
*Papilio troilus*
SPICEBUSH SWALLOWTAIL
RANGE: Eastern North America

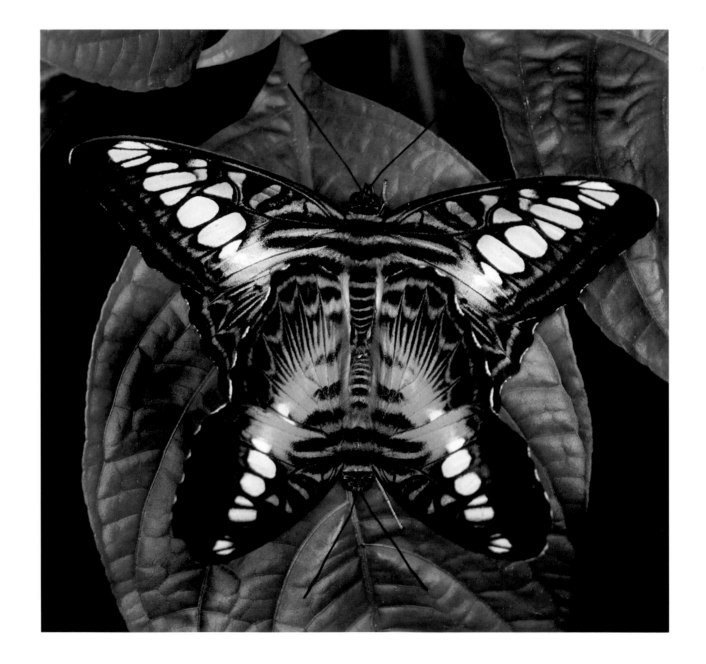

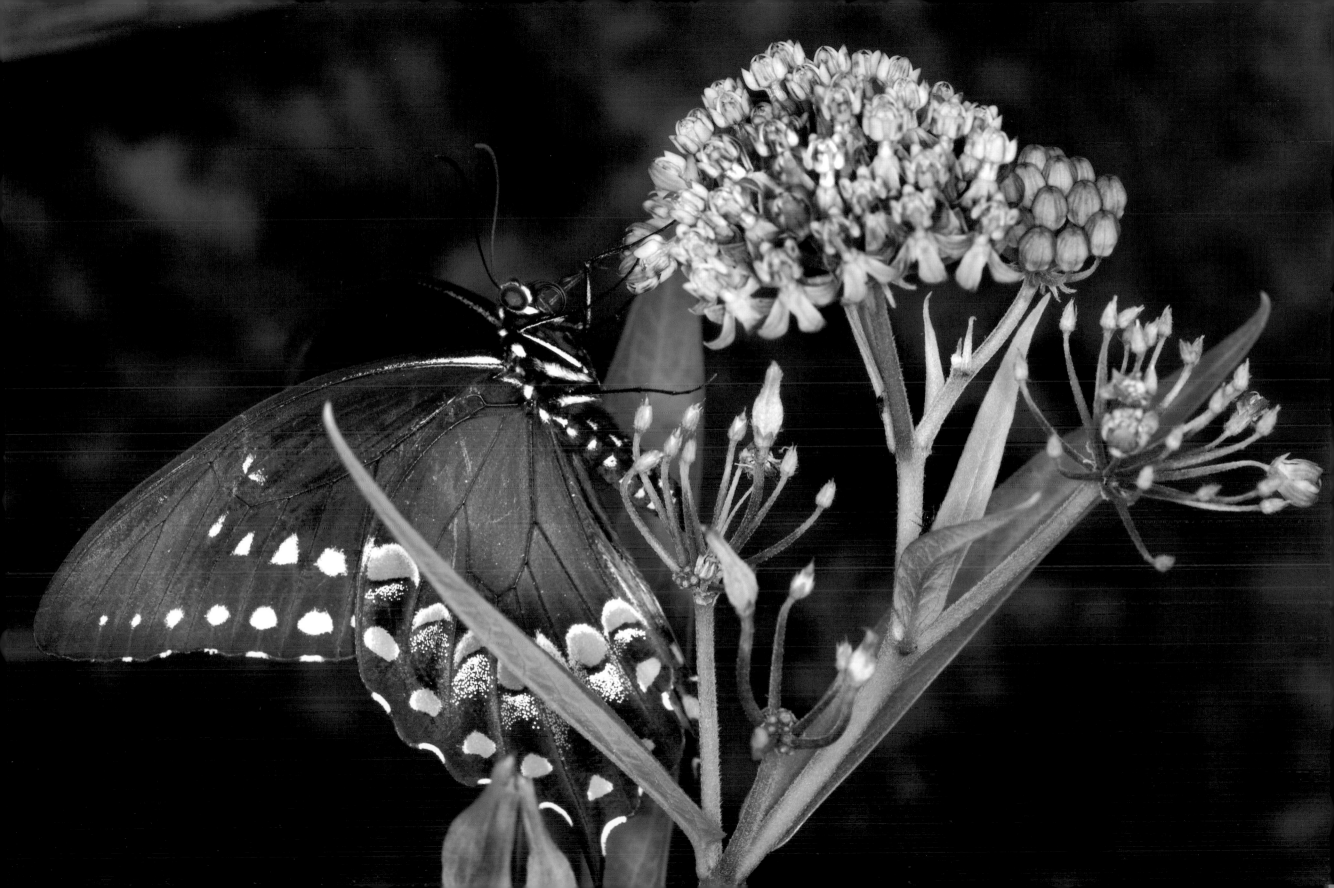

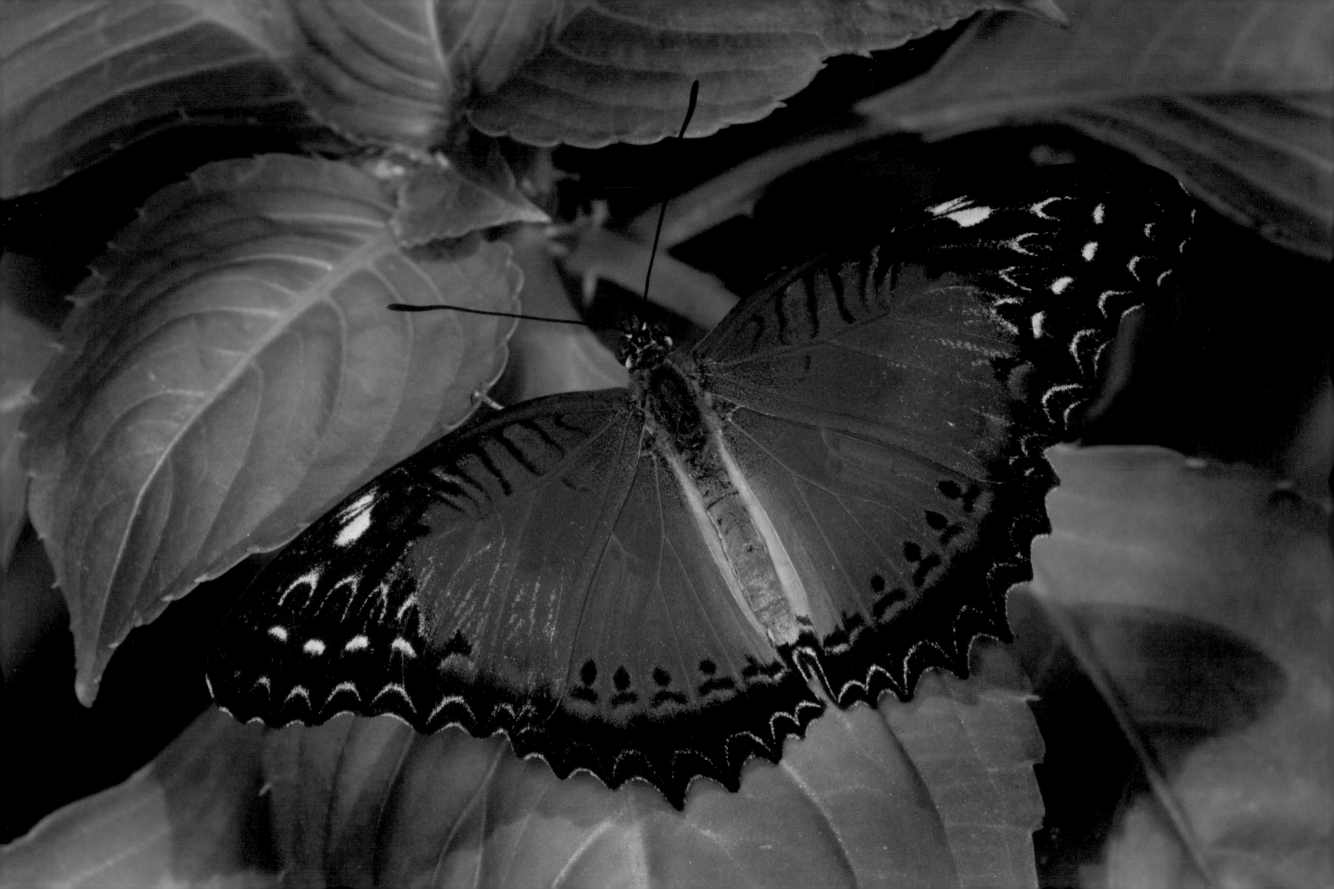

*Cethosia biblis*
RED LACEWING
RANGE: India to China, Indonesia,
Malaysia, and the Philippines

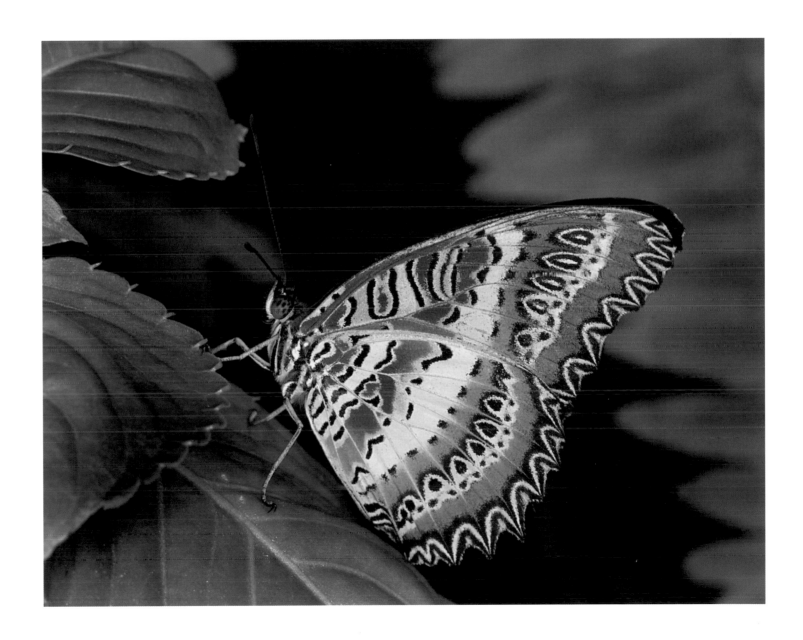

28

[right]
*Heliconius melpomene*
THE POSTMAN
RANGE: Central America to
southern Brazil

[opposite]
*Hamadryas amphinome*
RED CRACKER
RANGE: Texas to Argentina,
and Cuba

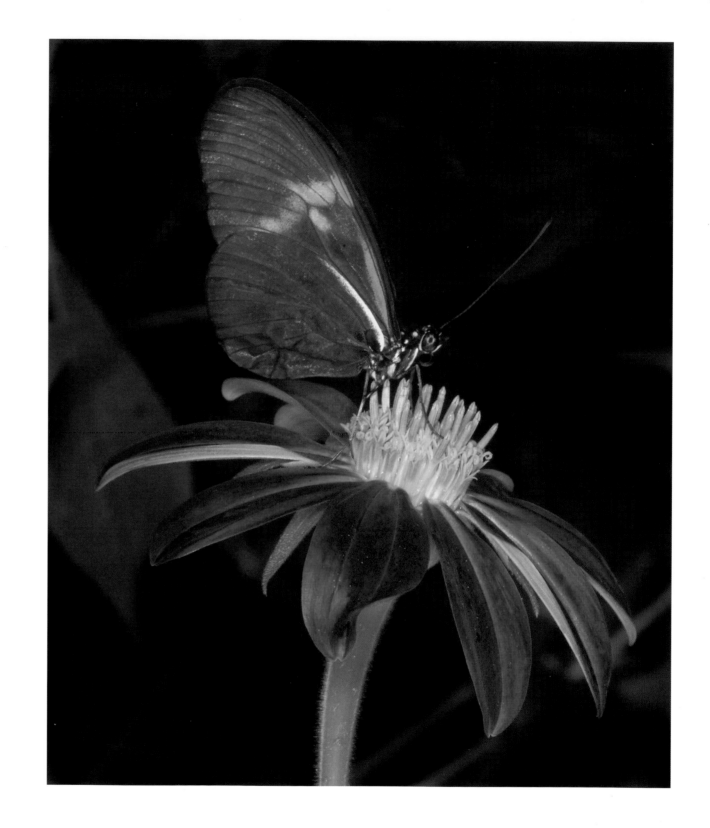

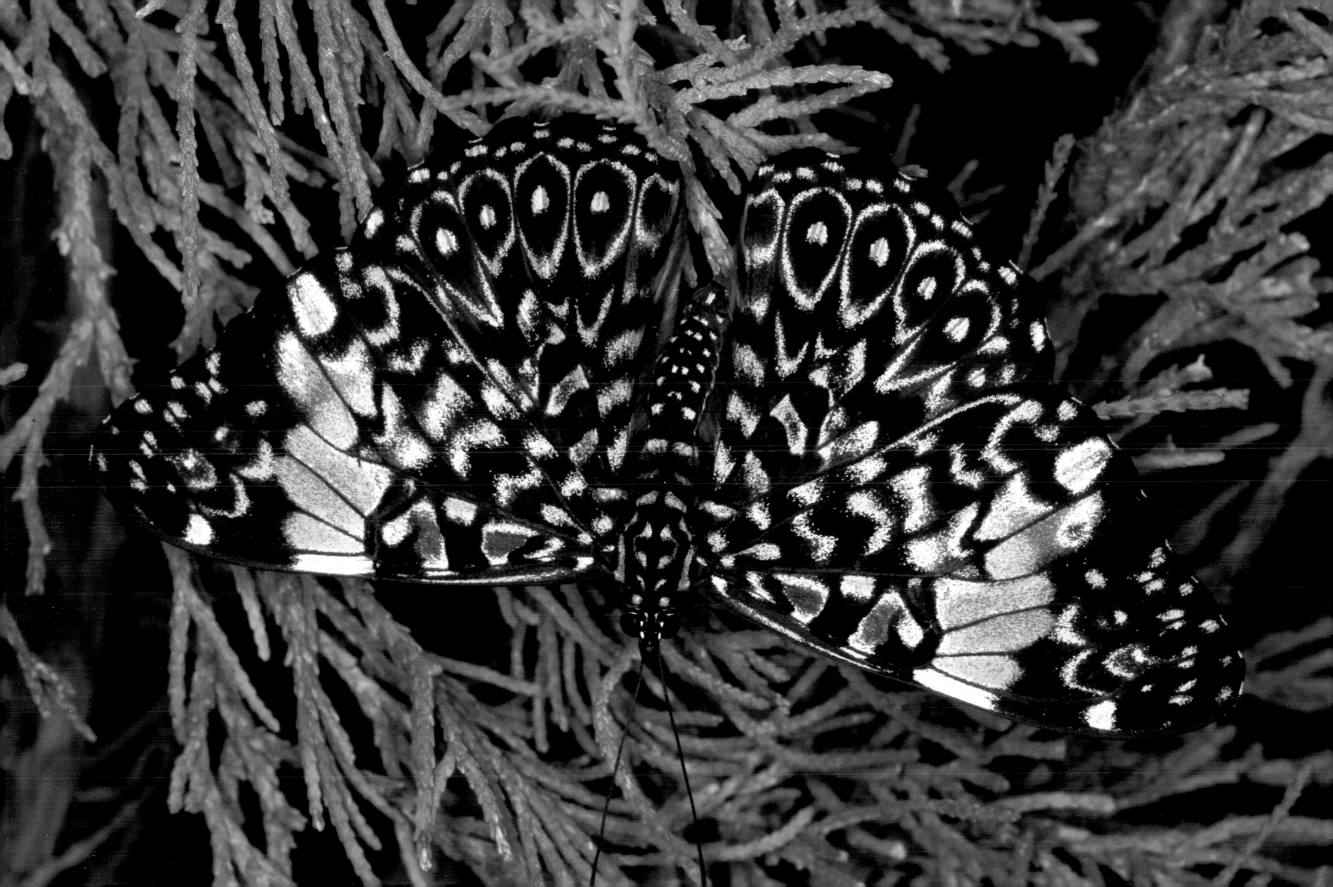

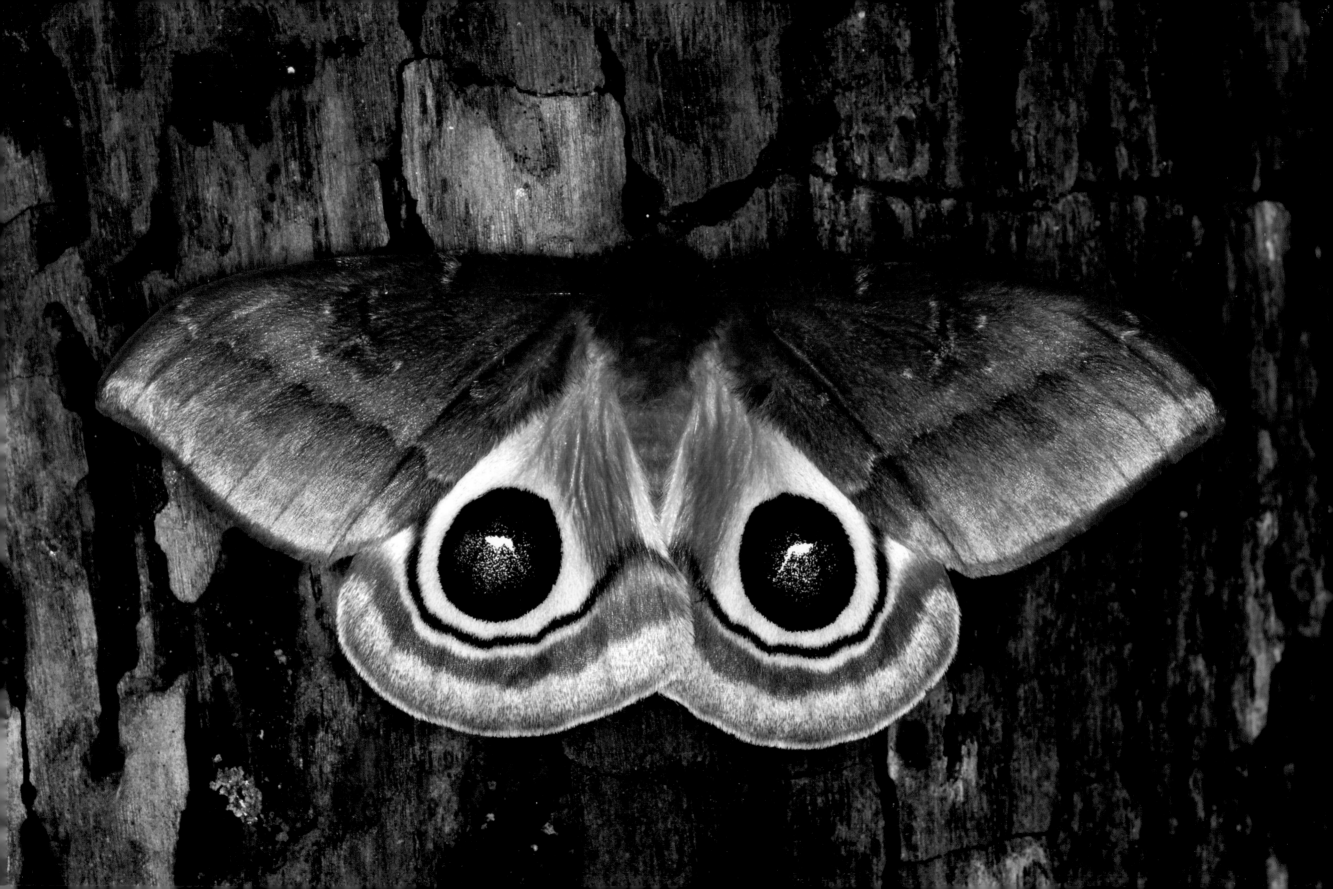

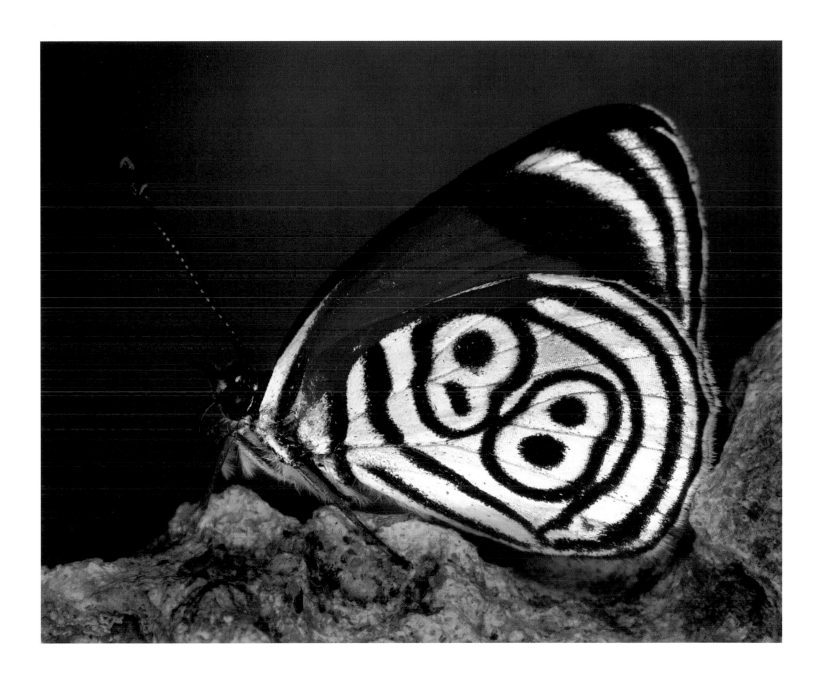

[opposite]
*Automeris io*
IO MOTH
RANGE: Southern Canada
to Mexico

[left]
*Diaethria clymena*
88 BUTTERFLY
RANGE: Central America,
Colombia to Paraguay

32

[right]
*Vindula erota*
CRUISER
RANGE: India, Pakistan, Malaysia,
and Indonesia

[opposite]
*Ornithoptera priamus euphorion*
CAIRNS BIRDWING
RANGE: Moluccas to Papua
New Guinea, the Solomon Islands,
and Australia

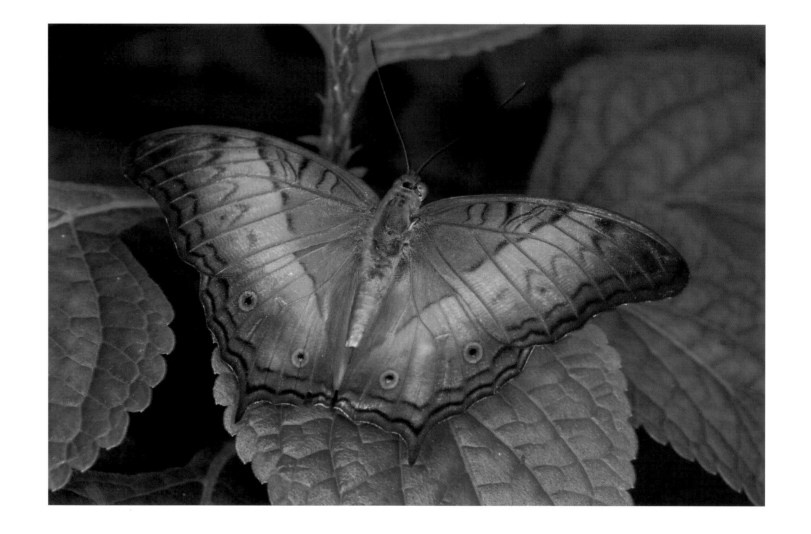

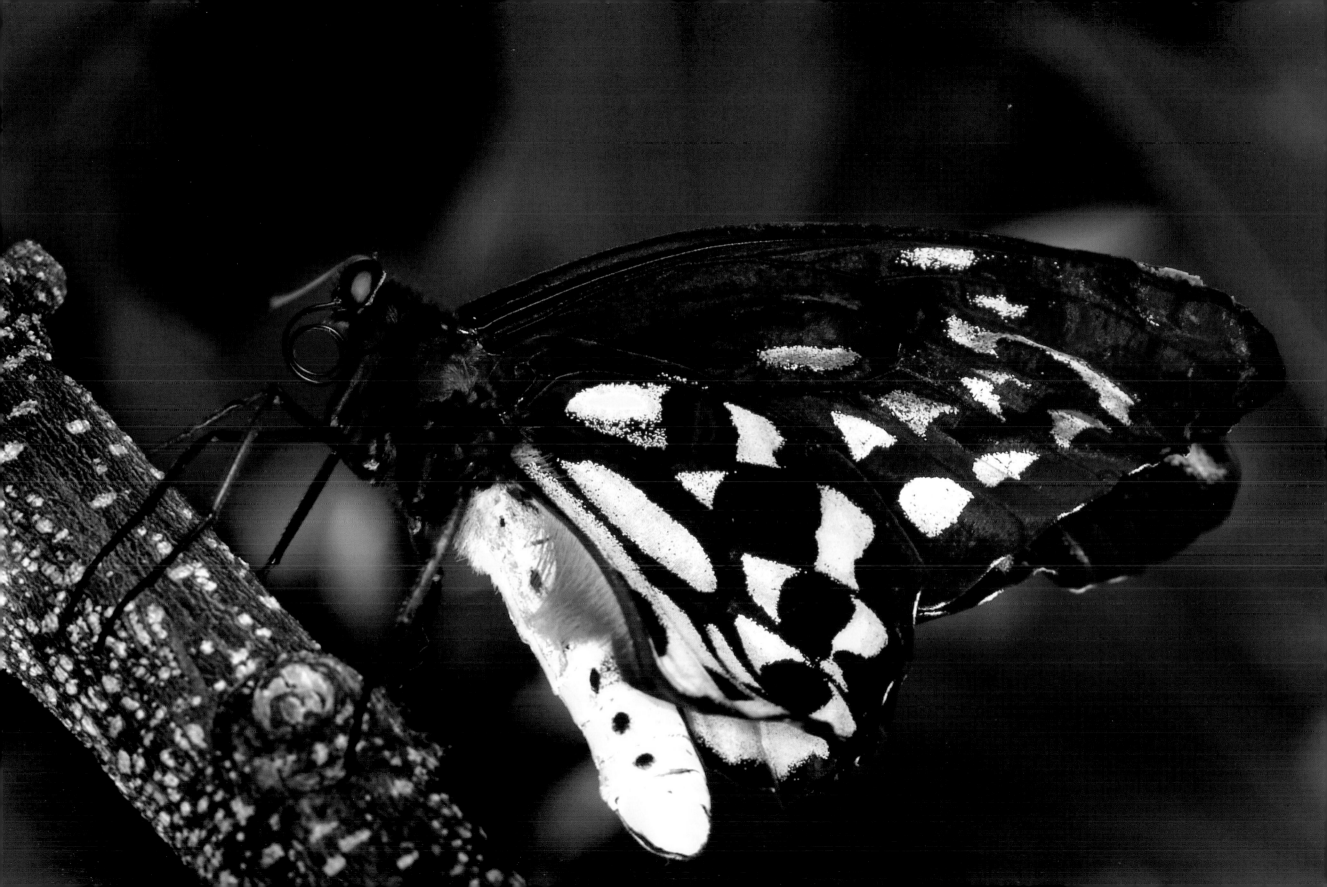

34   *Argema mittrei*
MADAGASCAN MOON MOTH
RANGE: Madagascar

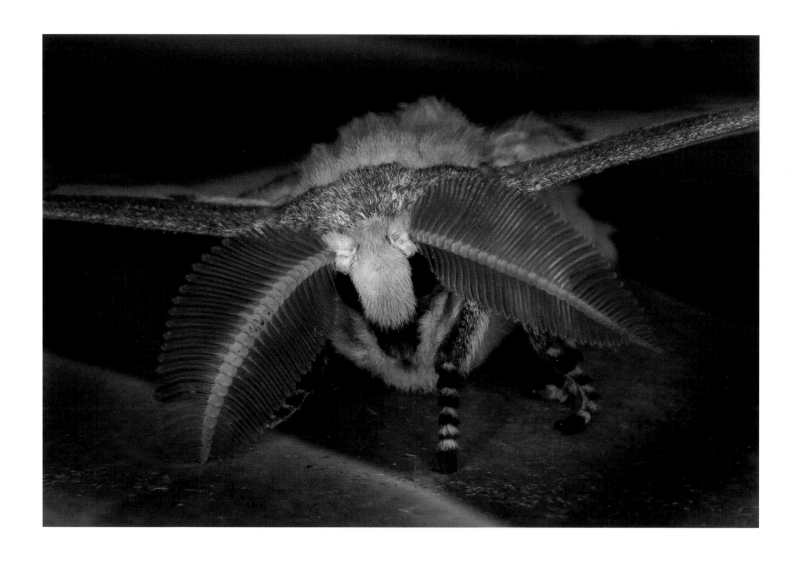

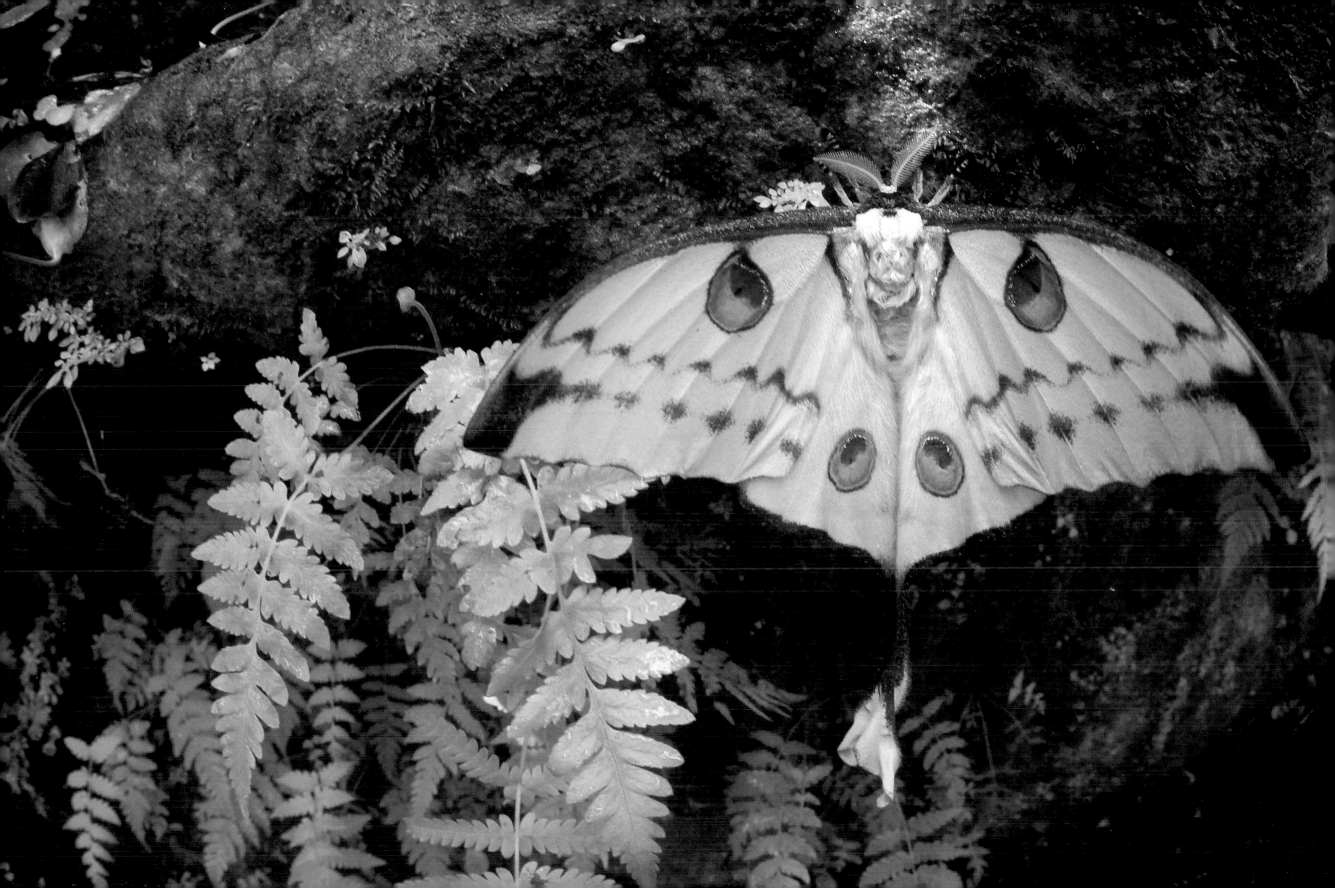

36  *Morpho peleides*
BLUE MORPHO
RANGE: Mexico to Colombia,
Venezuela, and Trinidad

What more felicity can fall to creature,
than to enjoy delight with liberty.

—Edmund Spenser, poet

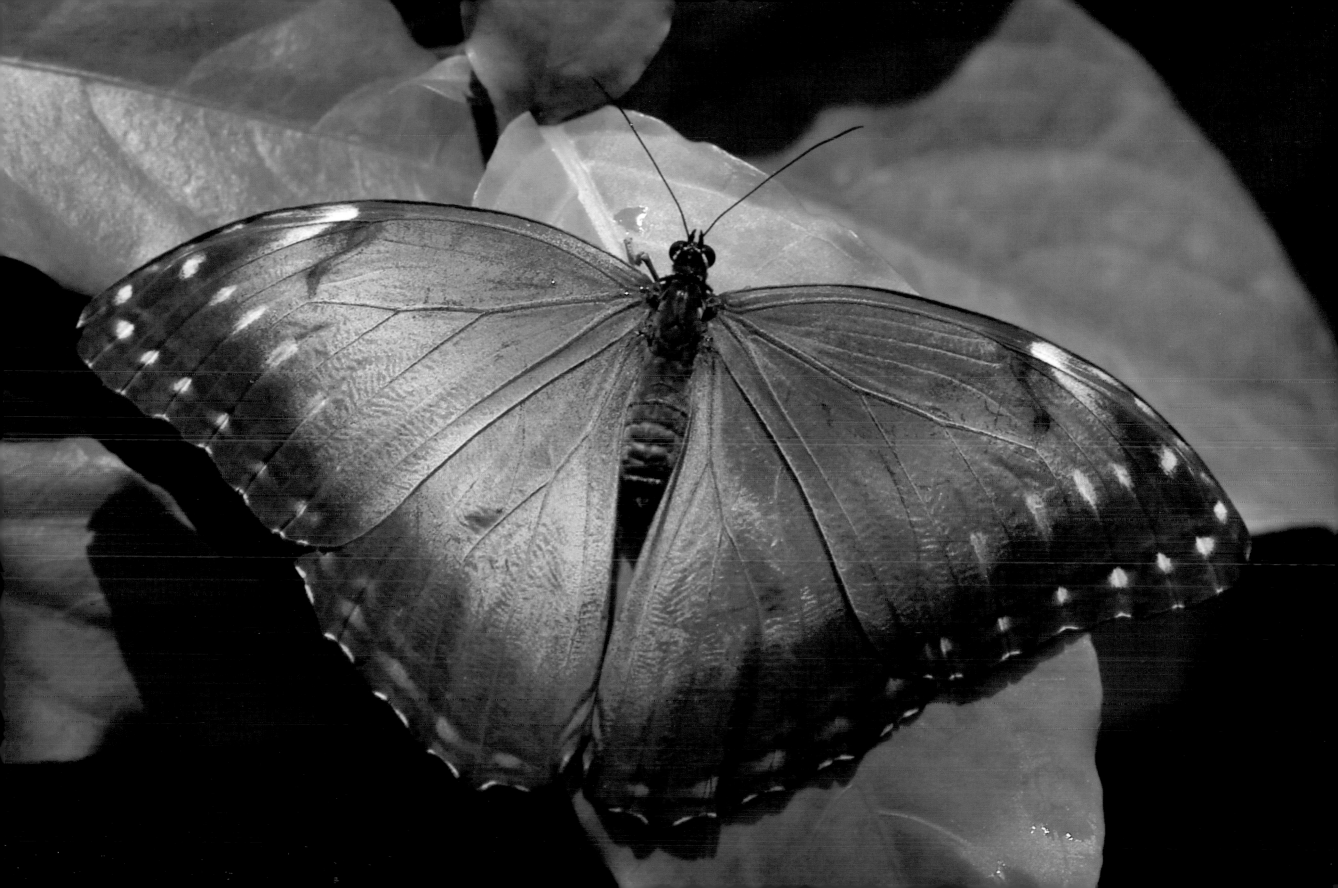

38 *Morpho peleides*
BLUE MORPHO
RANGE: Mexico to Colombia,
Venezuela, and Trinidad

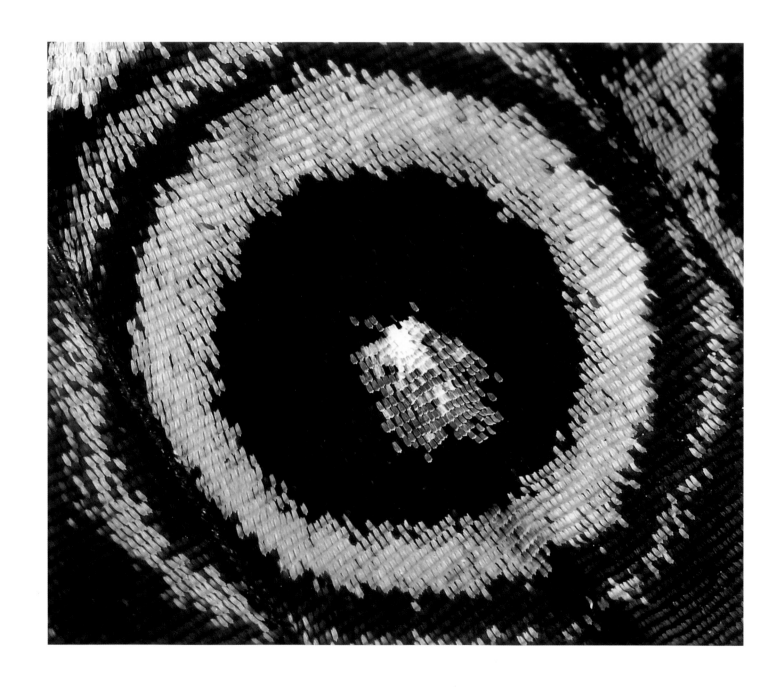

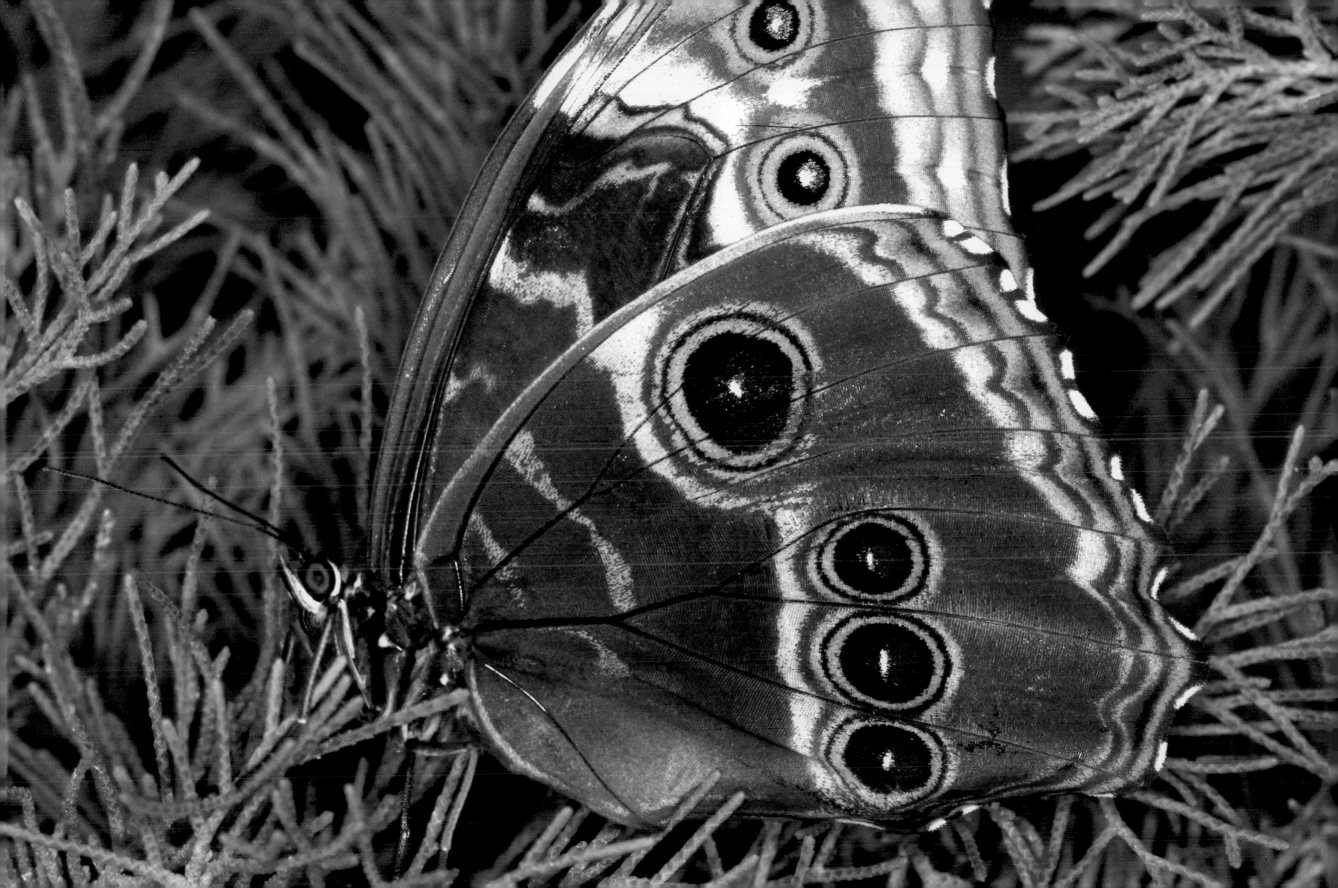

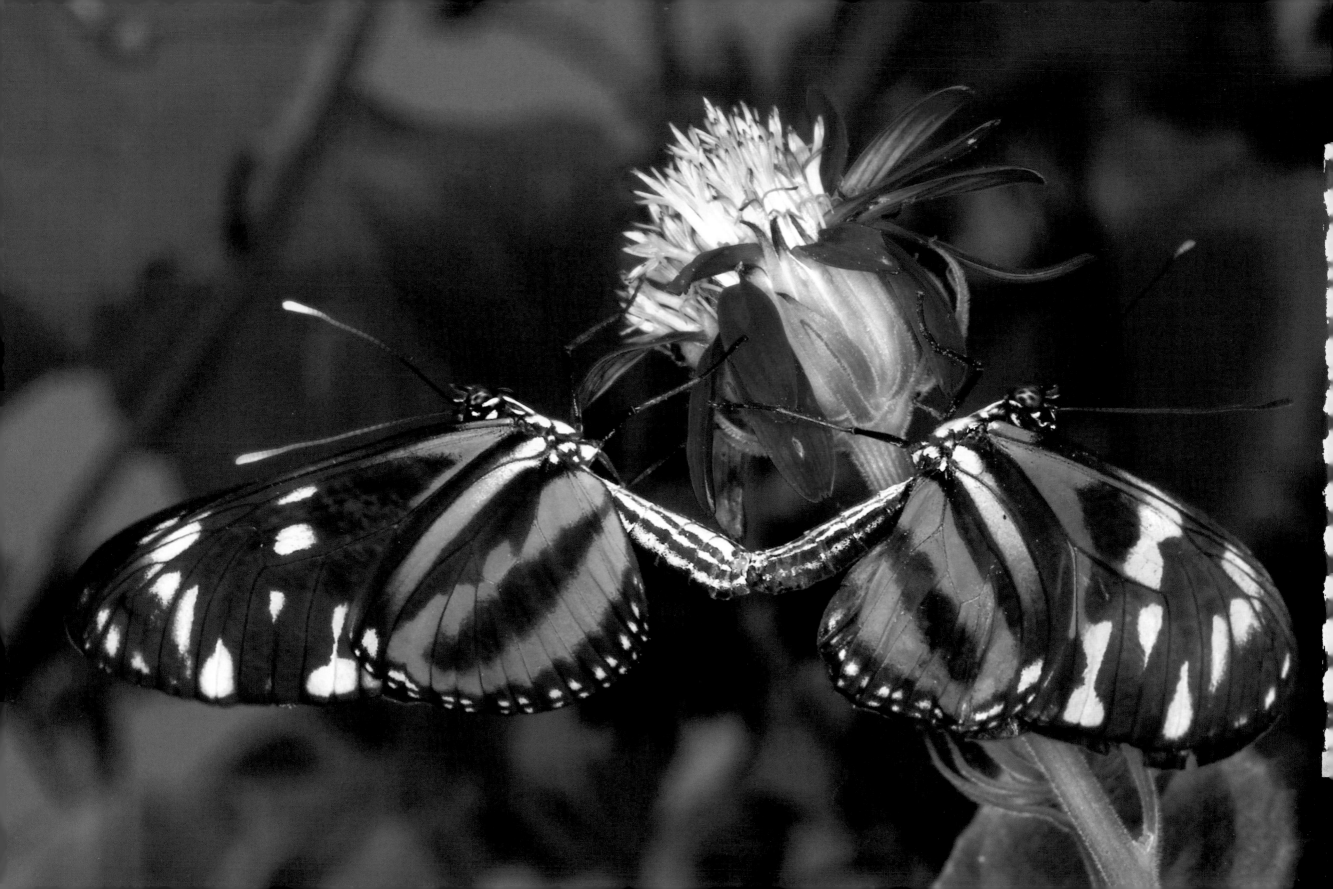

[opposite]
*Eveides isabella*
ISABELLA
RANGE: Central and South America

[right]
*Heliconius sara*
SARA
RANGE: Mexico to the Amazon Basin

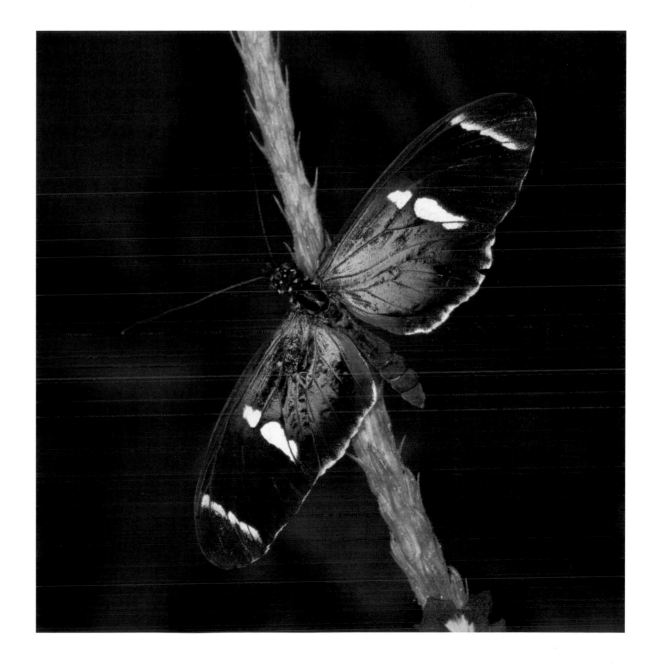

42 [right]
*Dryadula phaetusa*
BANDED ORANGE
RANGE: Mexico south to Paraguay

[opposite]
*Papilio palinurus*
THE BANDED PEACOCK
RANGE: Borneo and the Philippines;
Sri Lanka to Sumatra

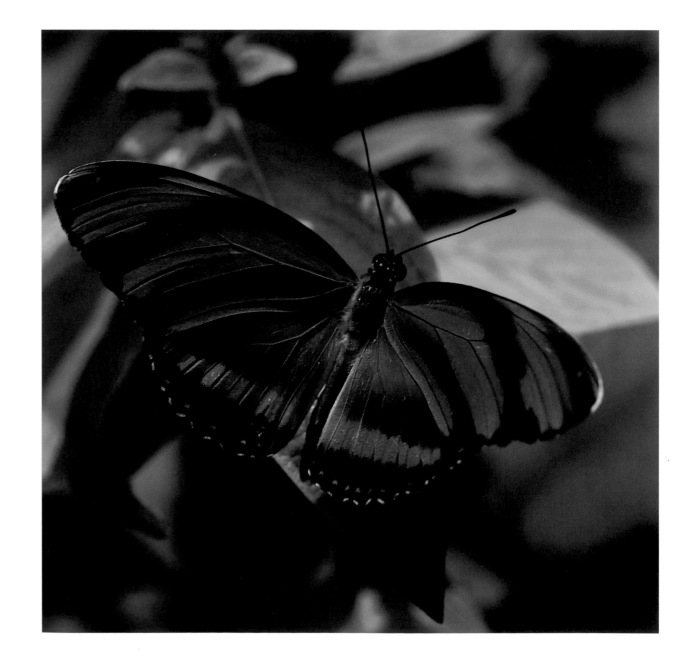

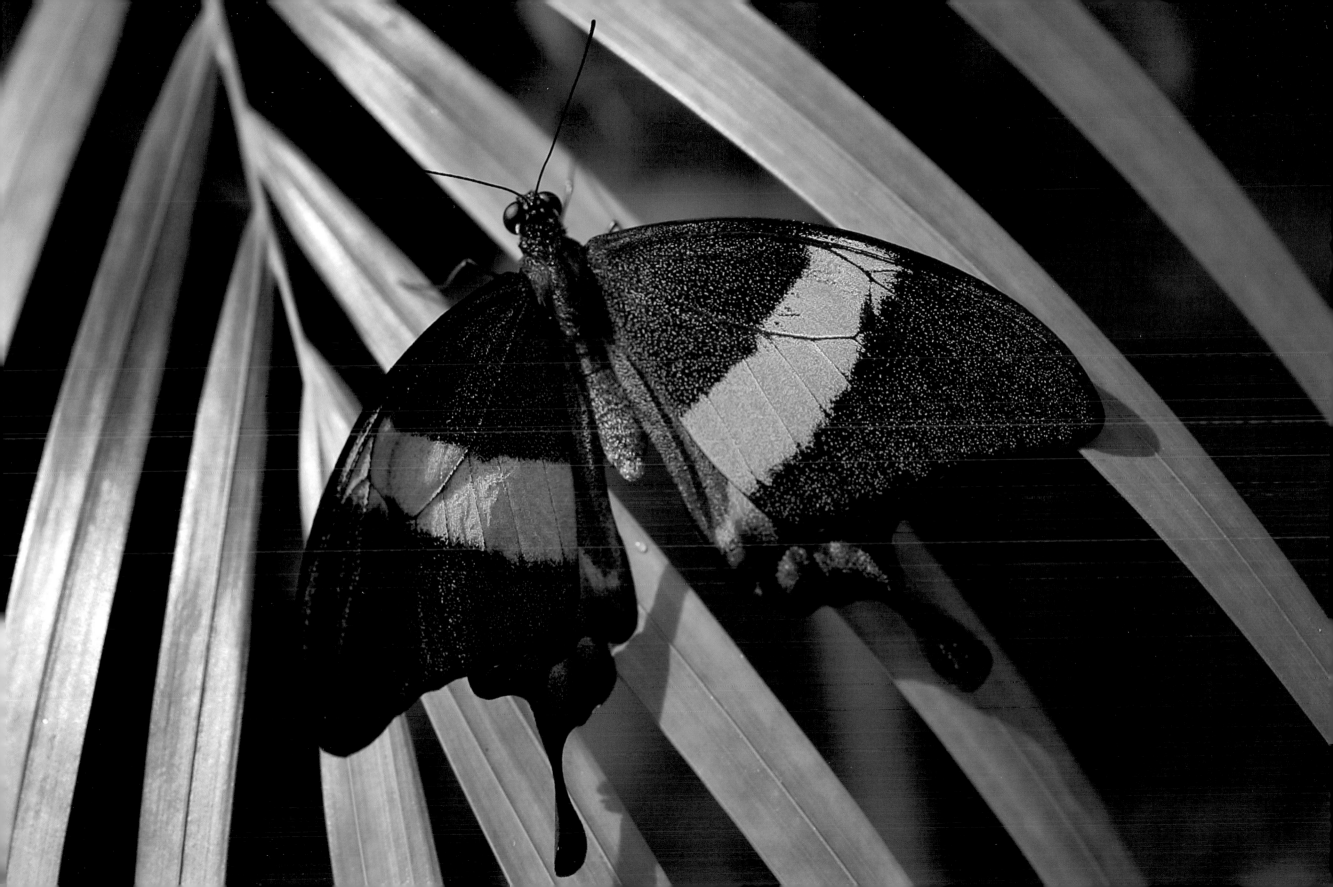

*Heliconius melpomene*
PIANO KEY
RANGE: This particular butterfly
is bred with patterns that vary from
its wild counterparts for display at
Butterfly World, Florida

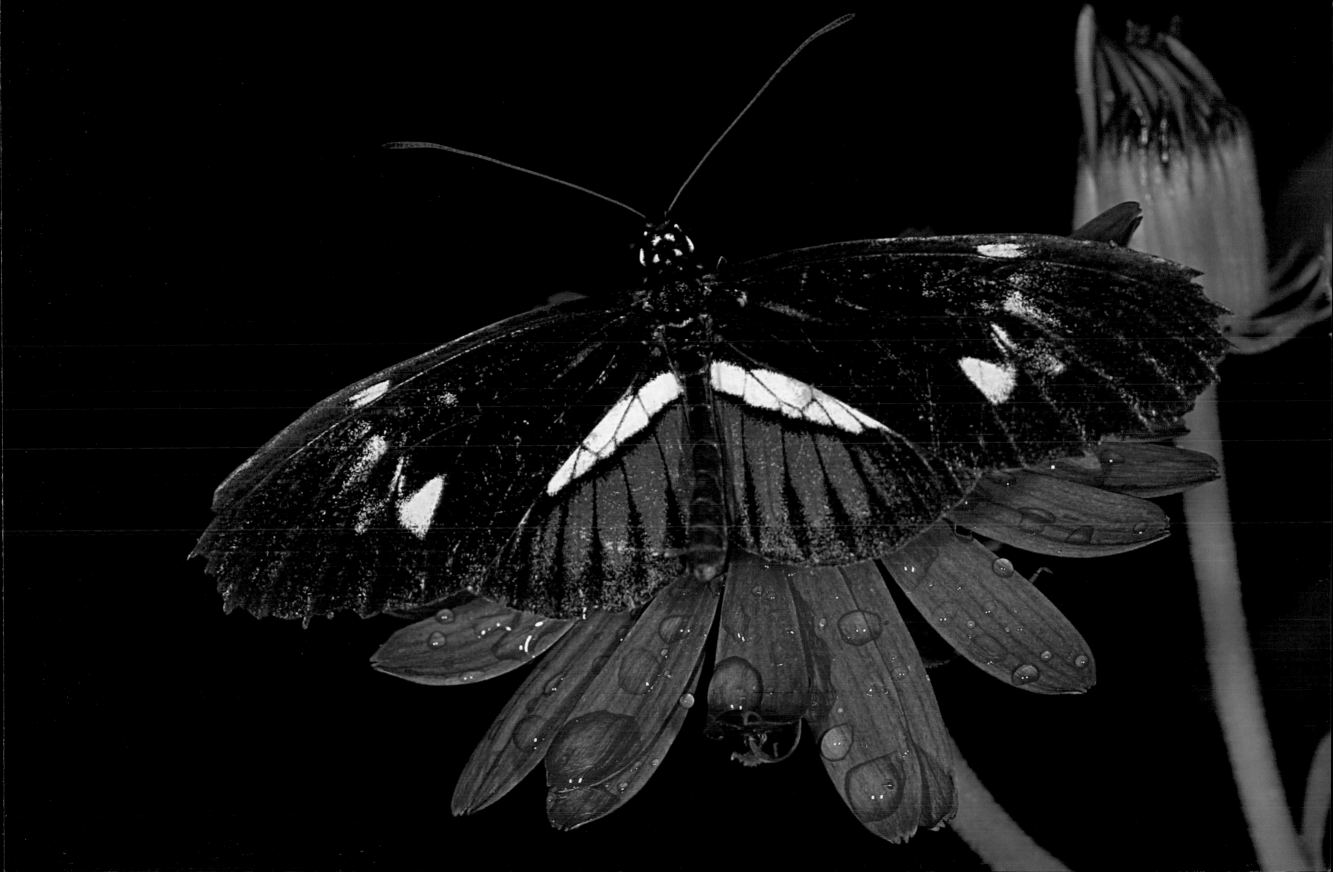

46 *Idea leuconoe*
LARGE TREE NYMPH
RANGE: Thailand to Malaysia,
Philippines, and Taiwan

You are like my soul,
a butterfly of dream.

—Pablo Neruda, poet

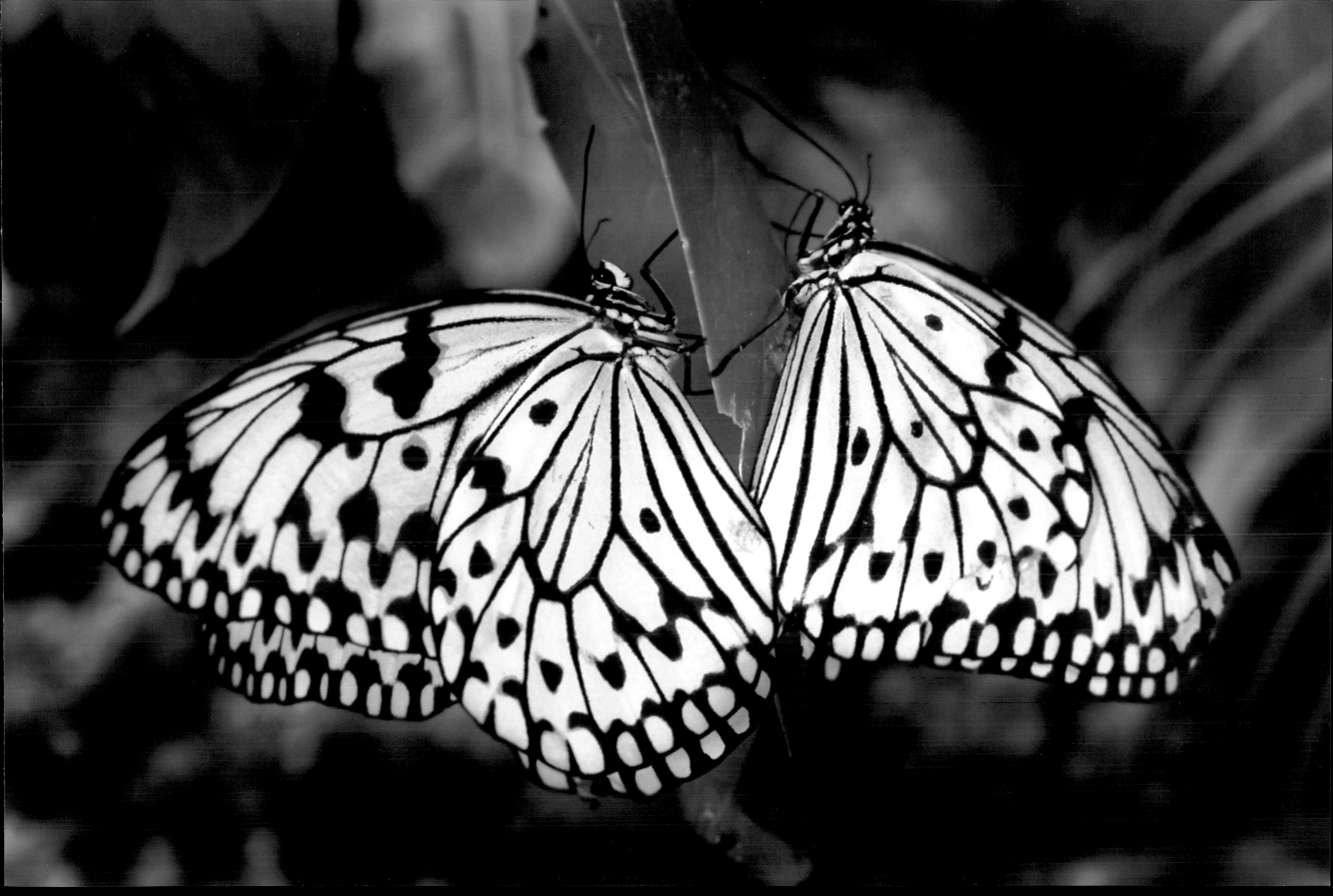

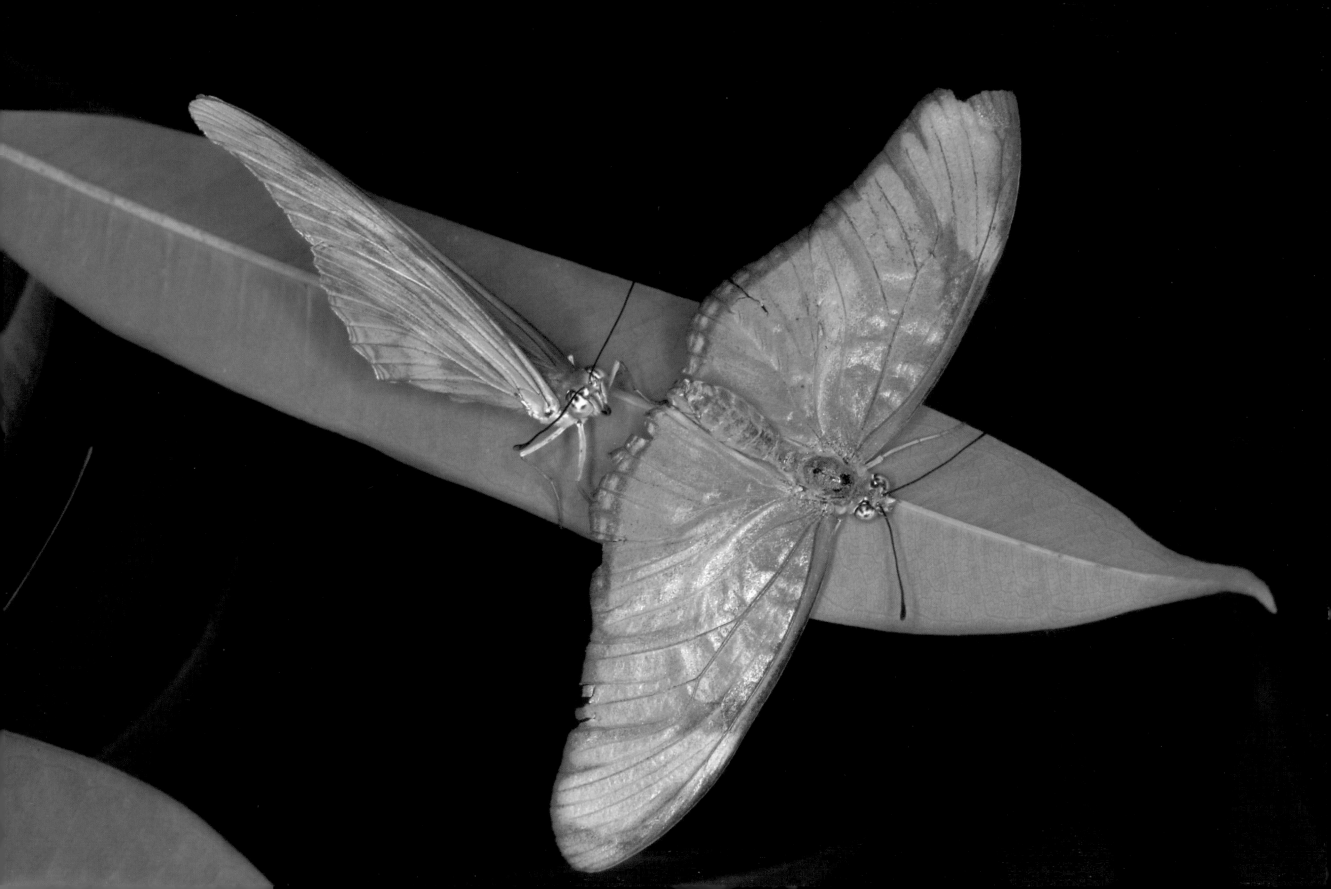

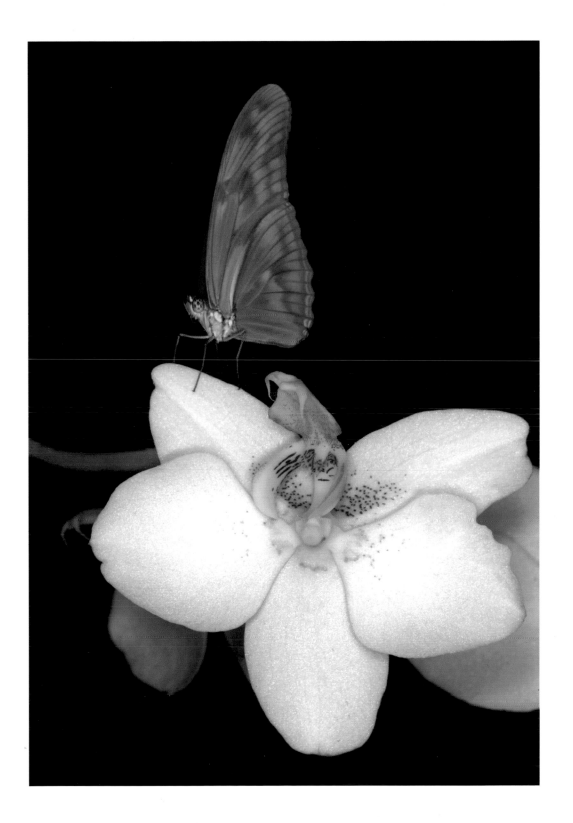

*Dryas iulia*       49
JULIA
RANGE: Central and South America,
Texas and Florida in the United States

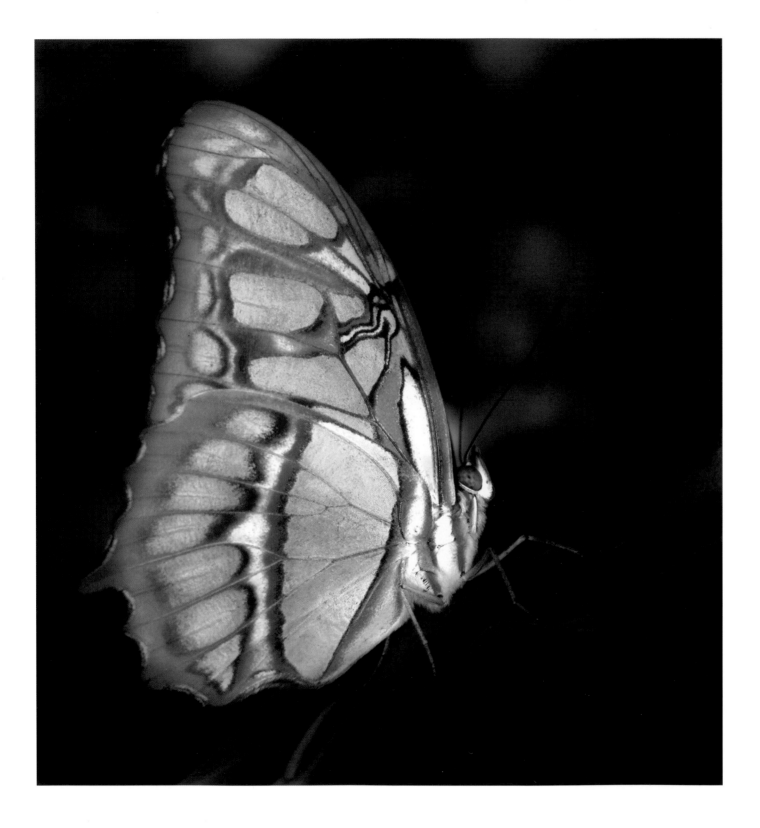

*Siproeta stelenes*
MALACHITE
RANGE: Southern United States
to the Amazon Basin

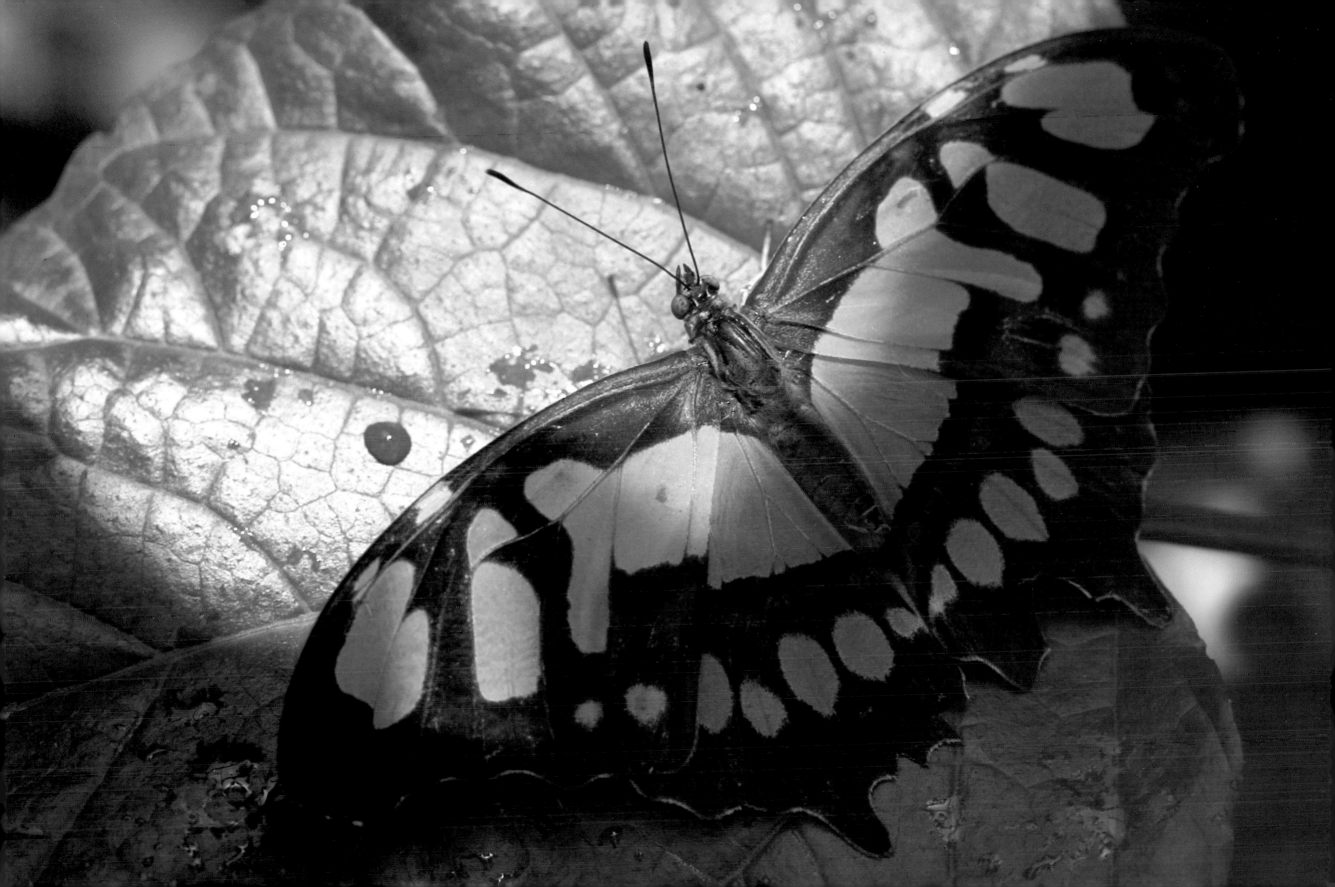

52    *Dryas iulia*
      JULIA
      RANGE: Central and South America,
      Texas and Florida in the United States

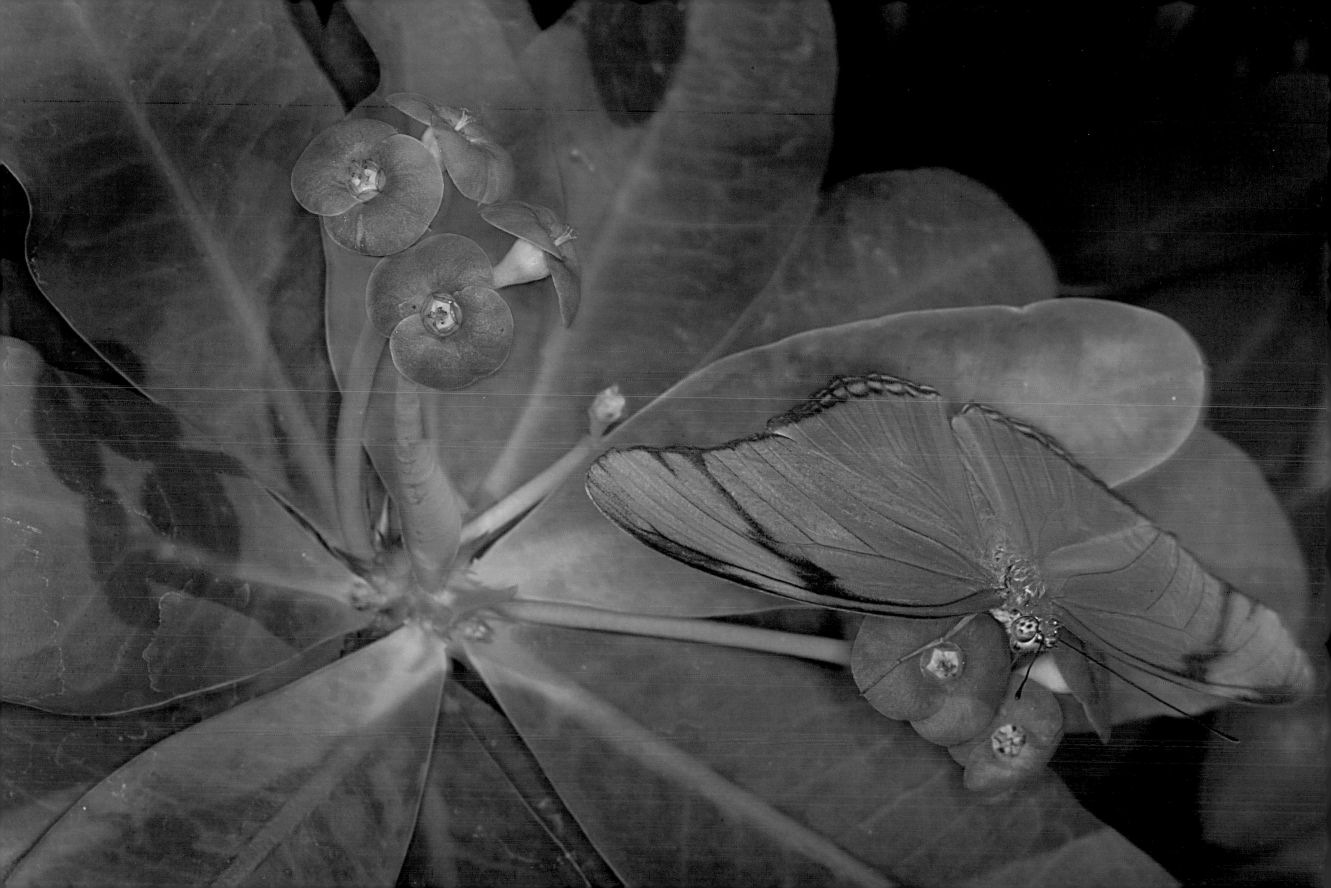

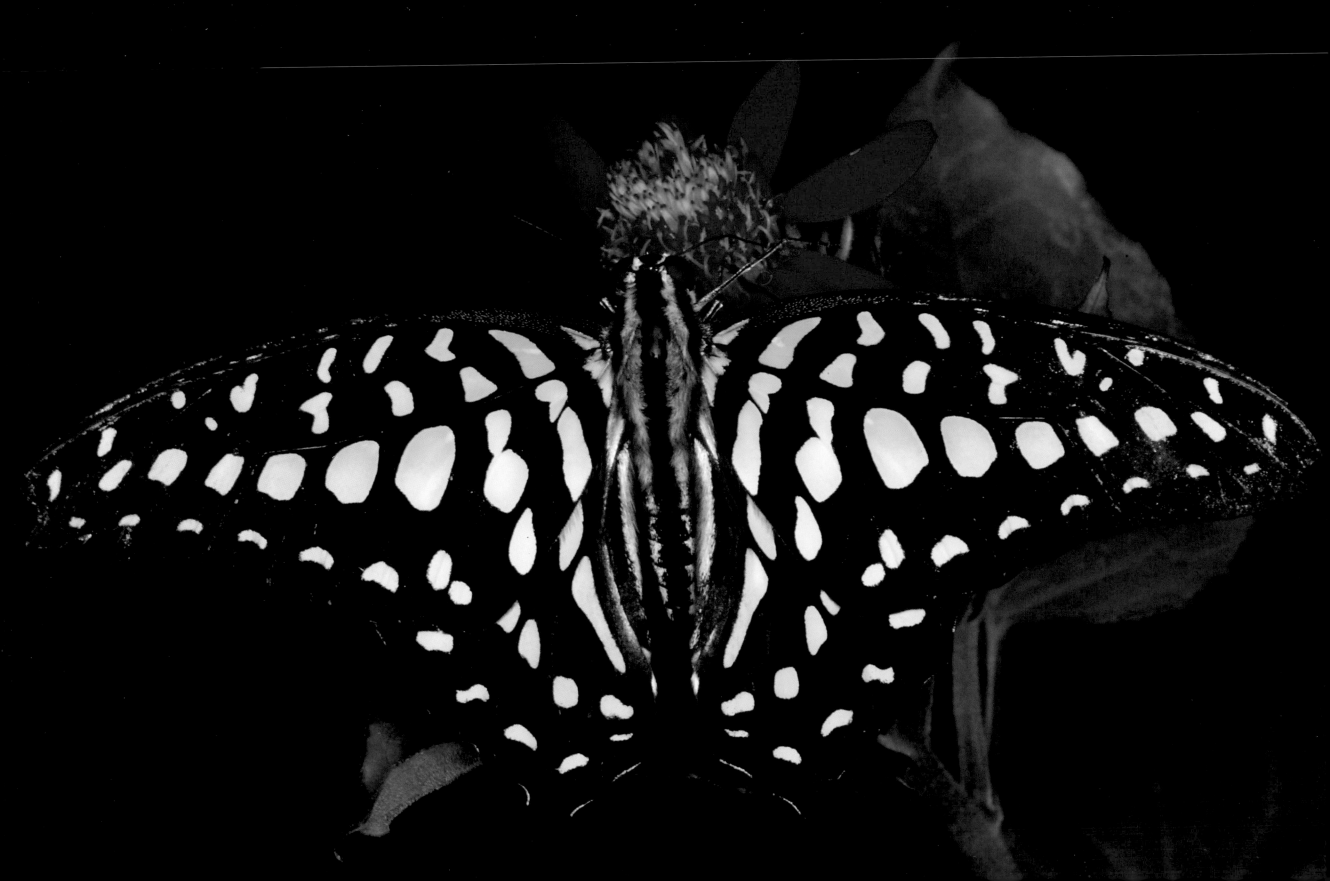

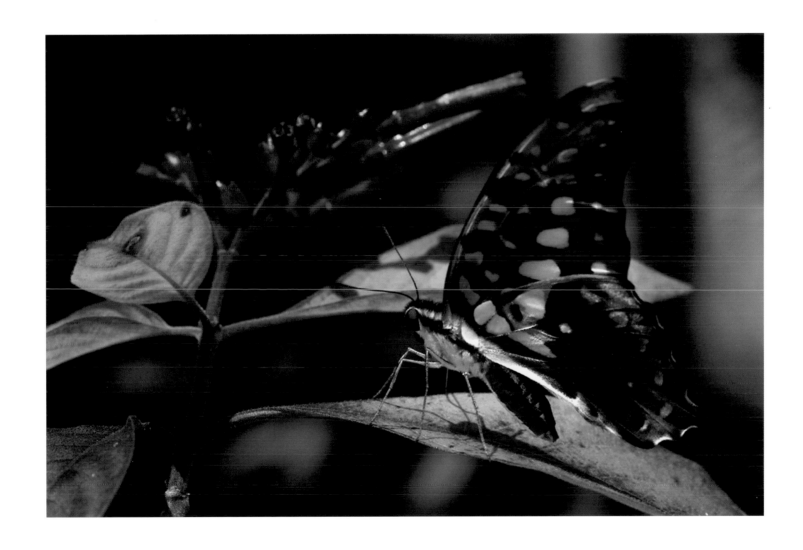

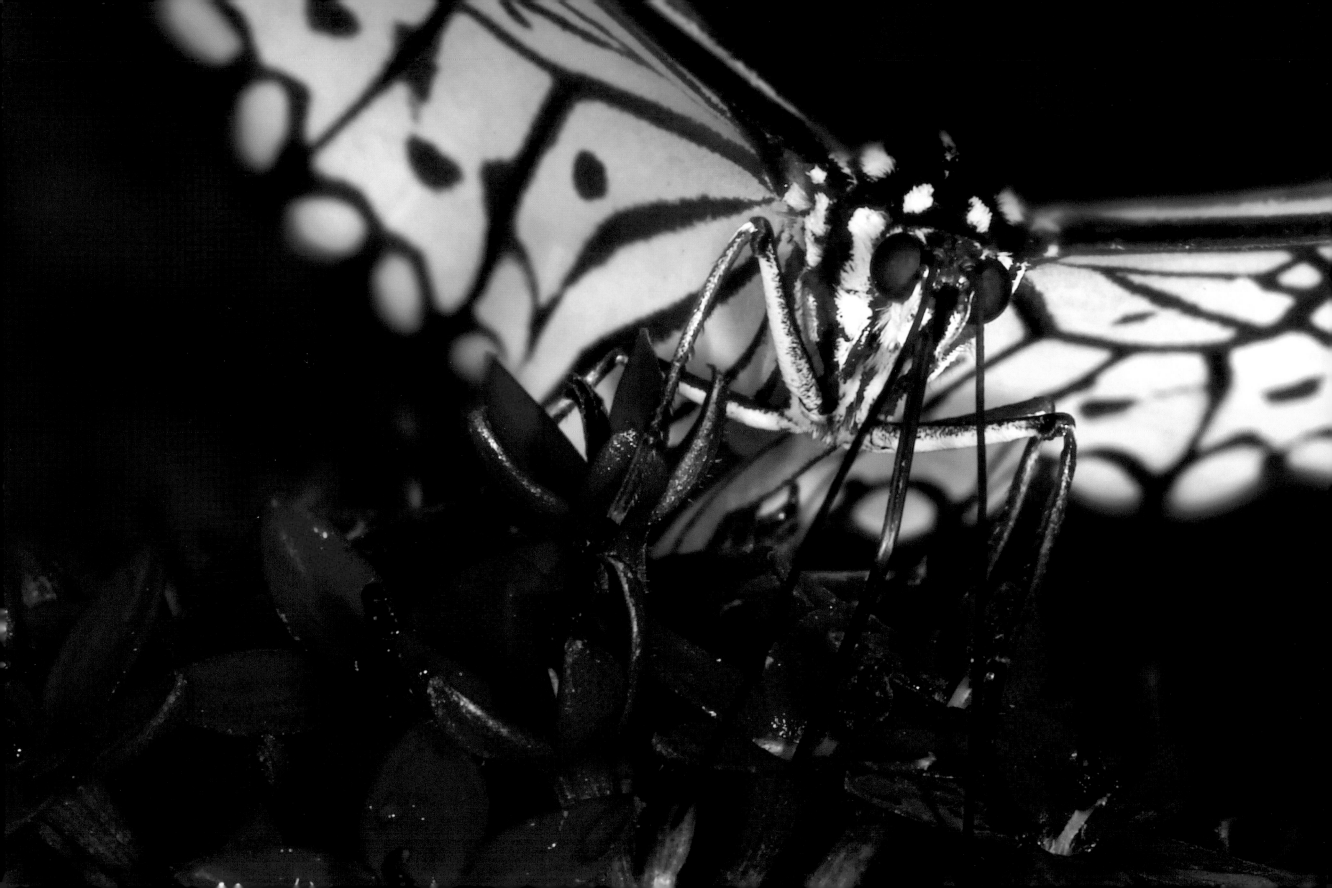

*Idea leuconoe*
LARGE TREE NYMPH
RANGE: Thailand to Malaysia,
Philippines, and Taiwan

58     *Heliconius charithonia*
ZEBRA LONGWING
RANGE: Southern United States,
Central and South America, and
the West Indies

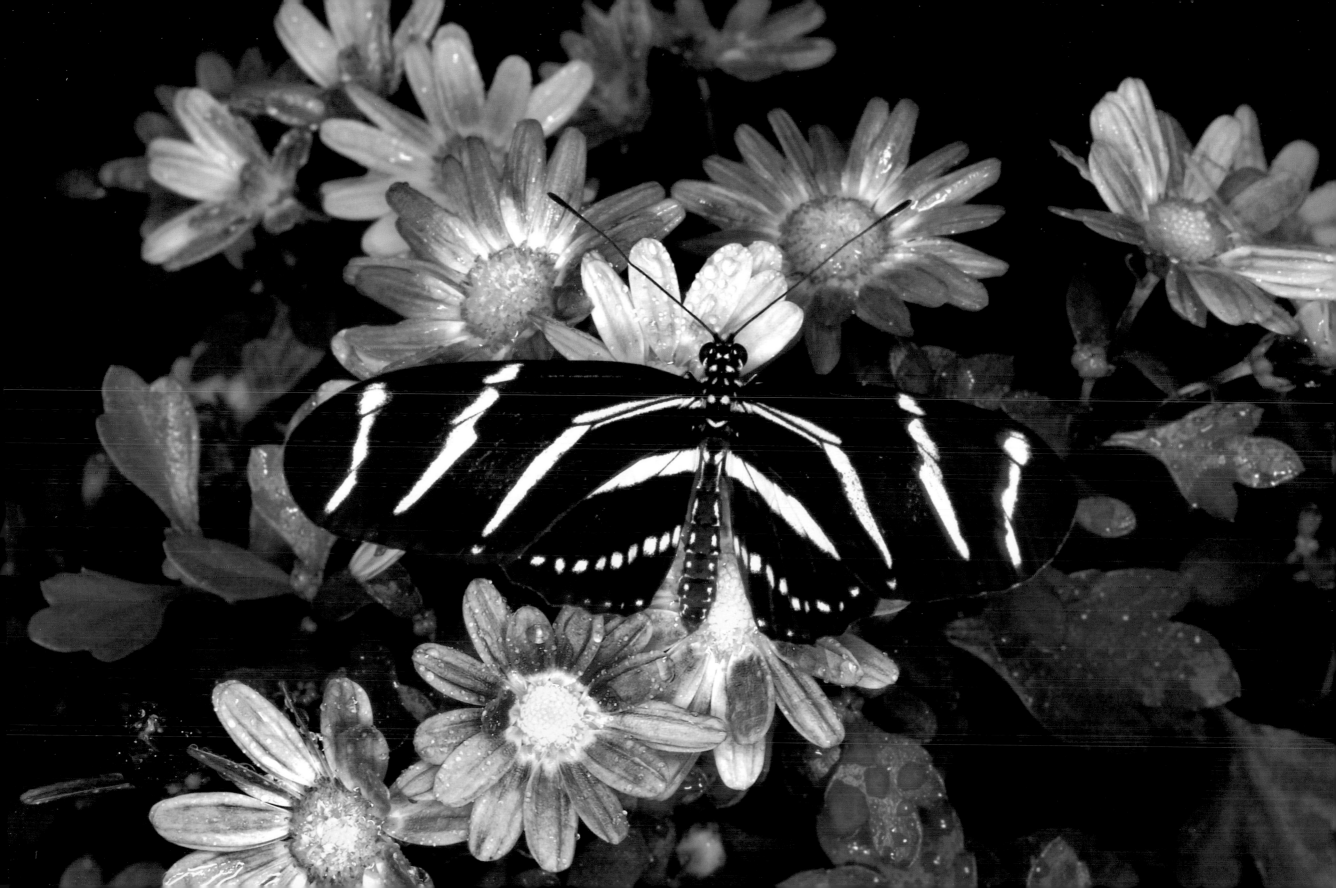

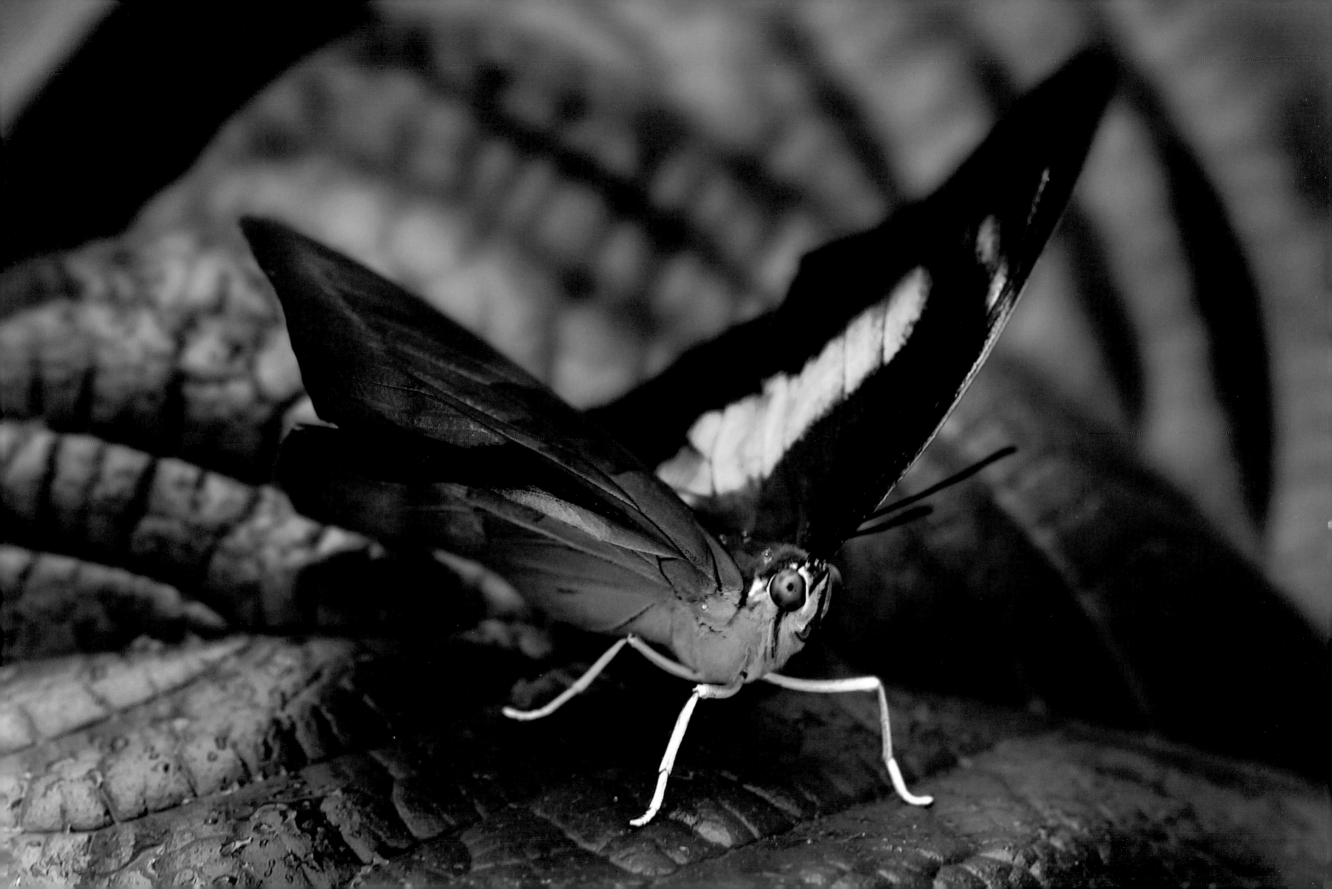

[opposite]
*Archaeoprepona demophon*
KING SHOEMAKER
RANGE: Mexico to Panama

[right]
*Hebomoia glaucippe*
GREAT ORANGE-TIP
RANGE: India to Malaysia, China,
the Philippines, and Japan

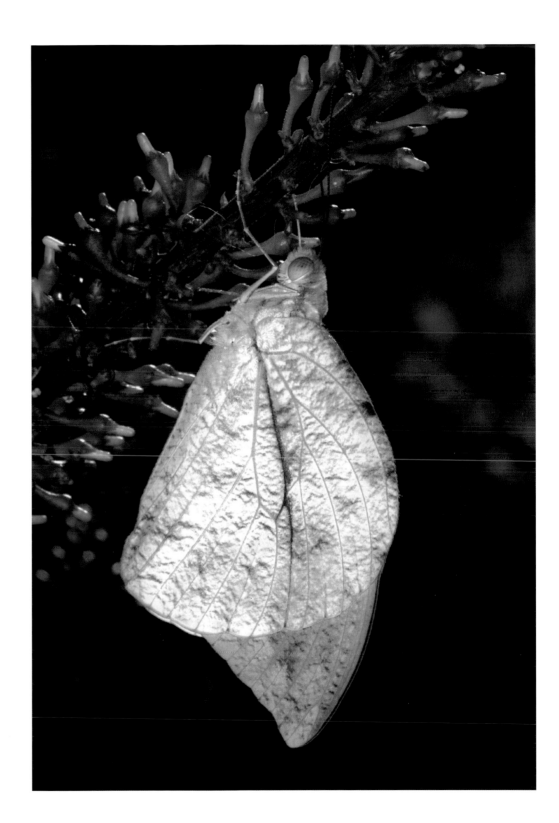

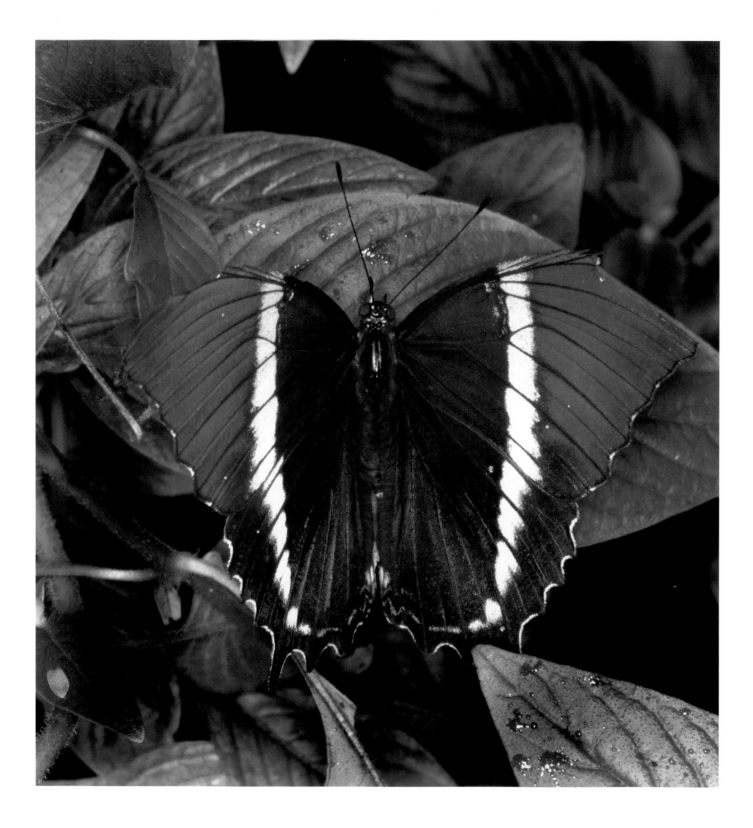

[left]
*Siproeta epaphus*
RUSTY-TIPPED PAGE
RANGE: Central and South America

[opposite]
*Precis atlites*
GREY PANSY
RANGE: India to Sundaland, Sulawesi,
and Lesser Sunda Islands

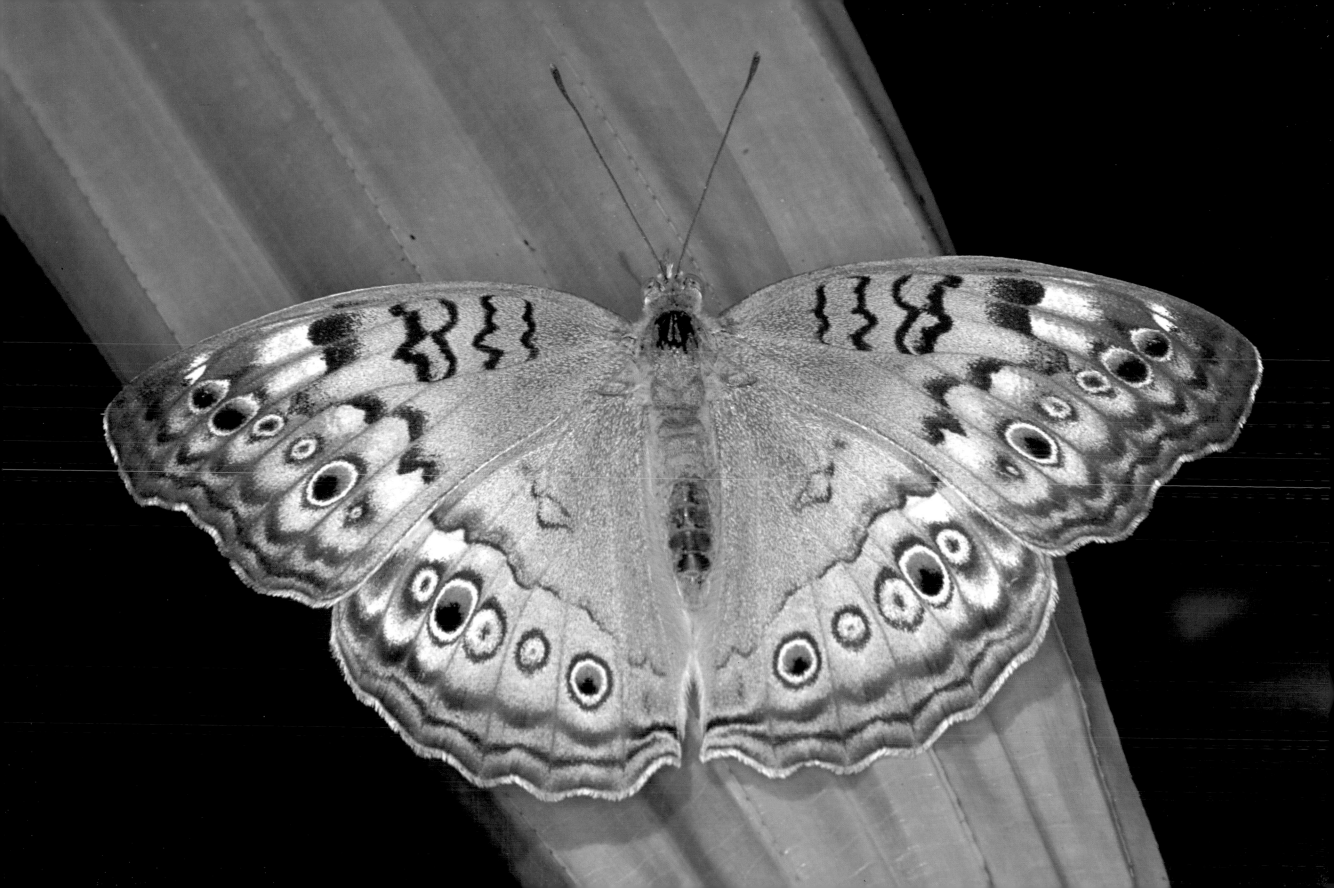

64    *Morpho polyphemus*
WHITE MORPHO
RANGE: Mexico to Costa Rica

The butterfly counts not the months
but moments, and has time enough.

—Rabindranath Tagore, poet

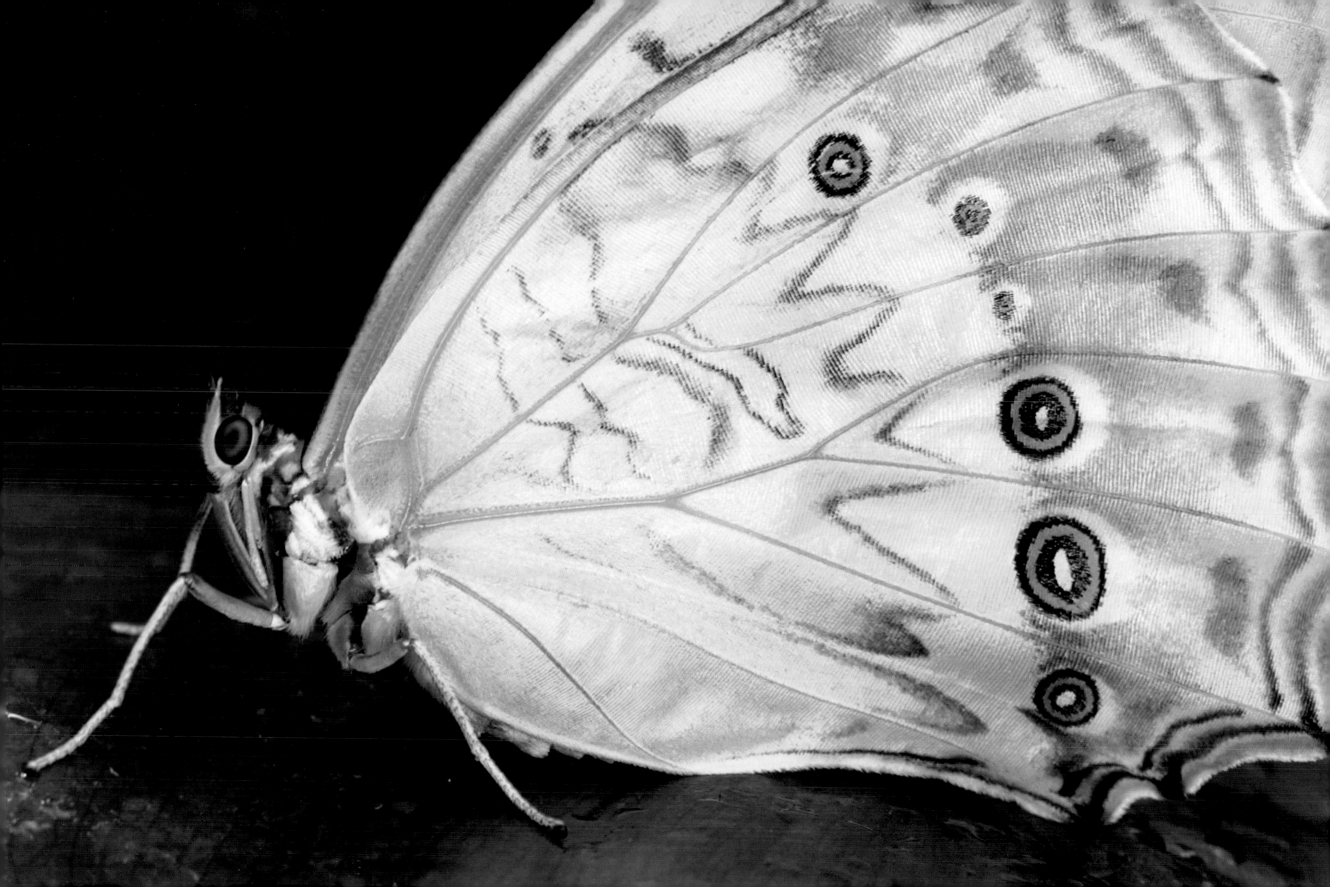

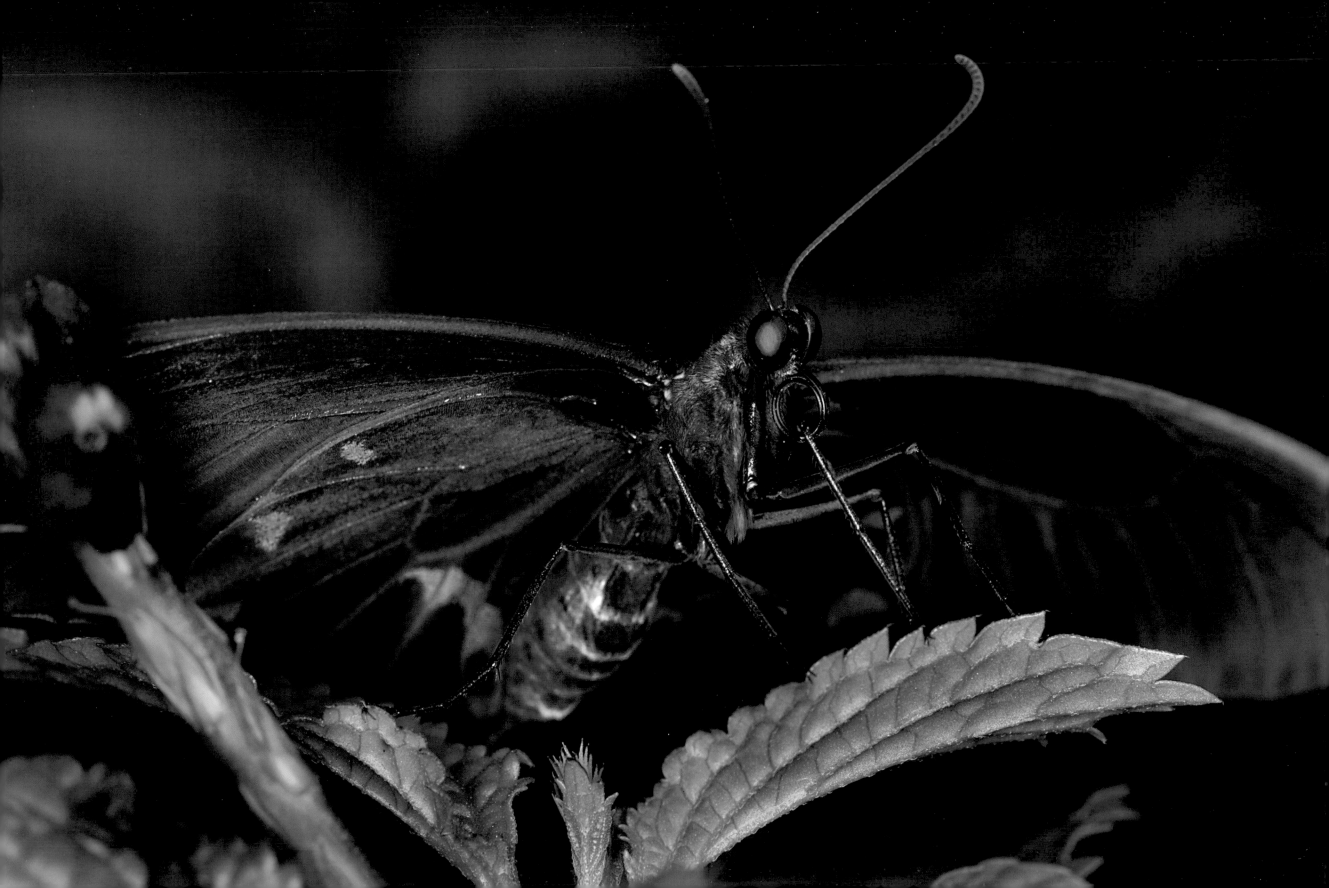

[opposite]
*Pachliopta kotzebuea*
PINK ROSE
RANGE: India, Sri Lanka to China and
Malaysia, and the Lesser Sunda Islands

[right]
*Pachliopta aristolochiae*
COMMON ROSE
RANGE: India, Sri Lanka to China and
Malaysia, and the Lesser Sunda Islands

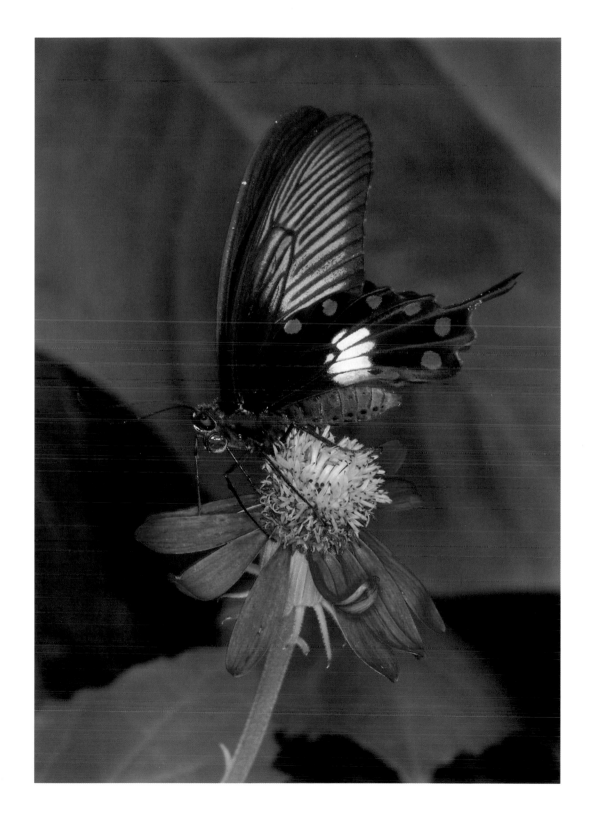

68

[right]
*Doleschalia bisaltide*
AUTUMN LEAF
RANGE: India and Sri Lanka to Thailand, Indonesia, the Philippines, the Solomon Islands, and Vanuata

[opposite]
*Troides helena*
COMMON BIRDWING
RANGE: India to Sundaland, and Sulawesi

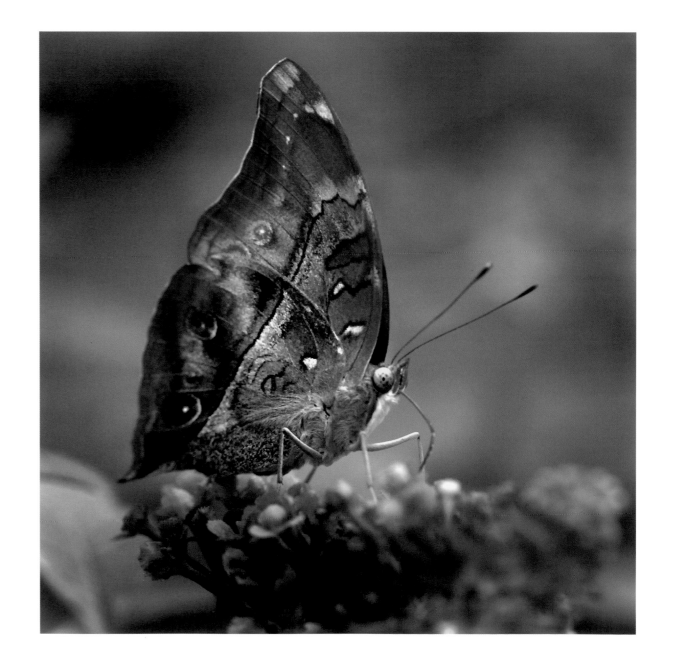

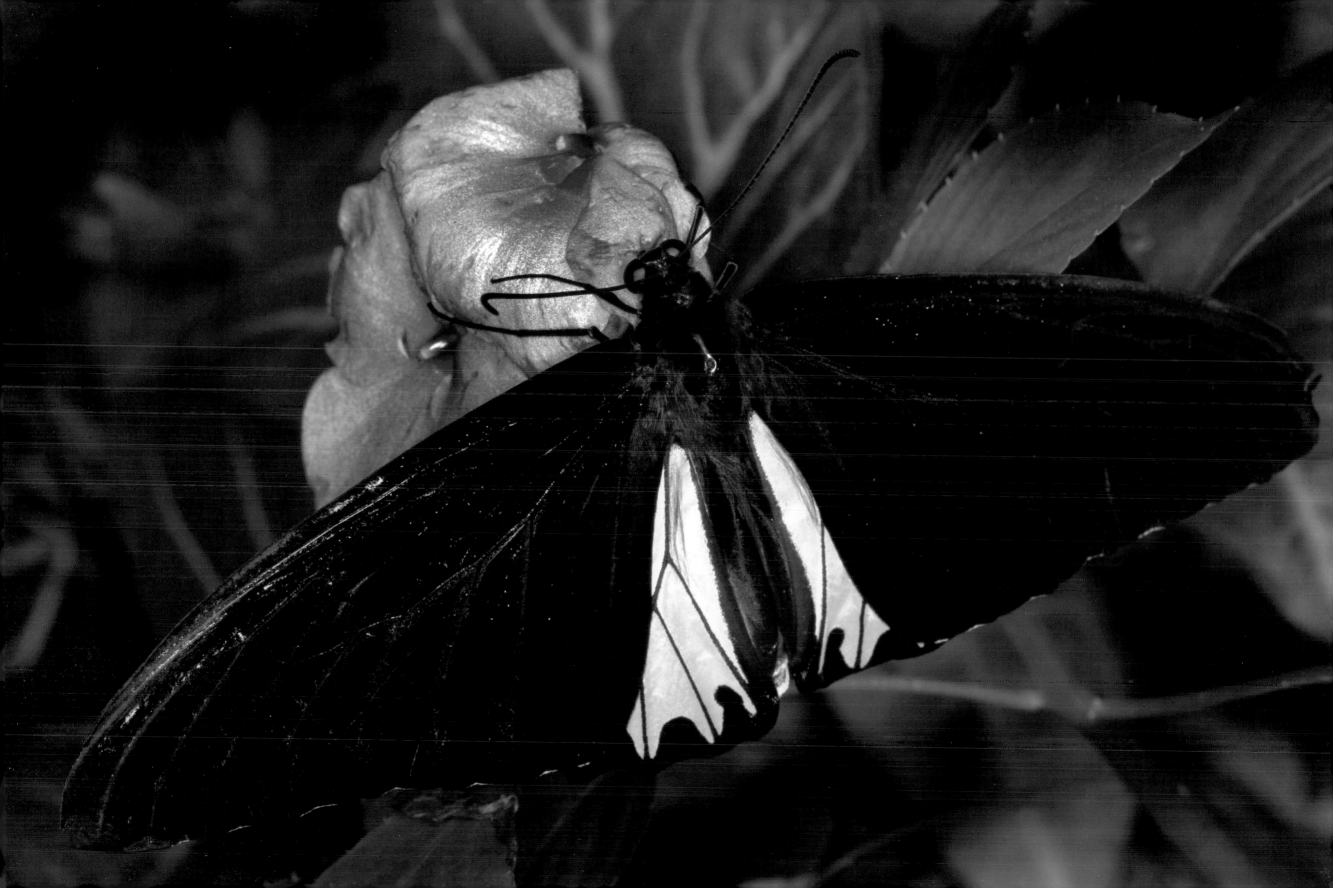

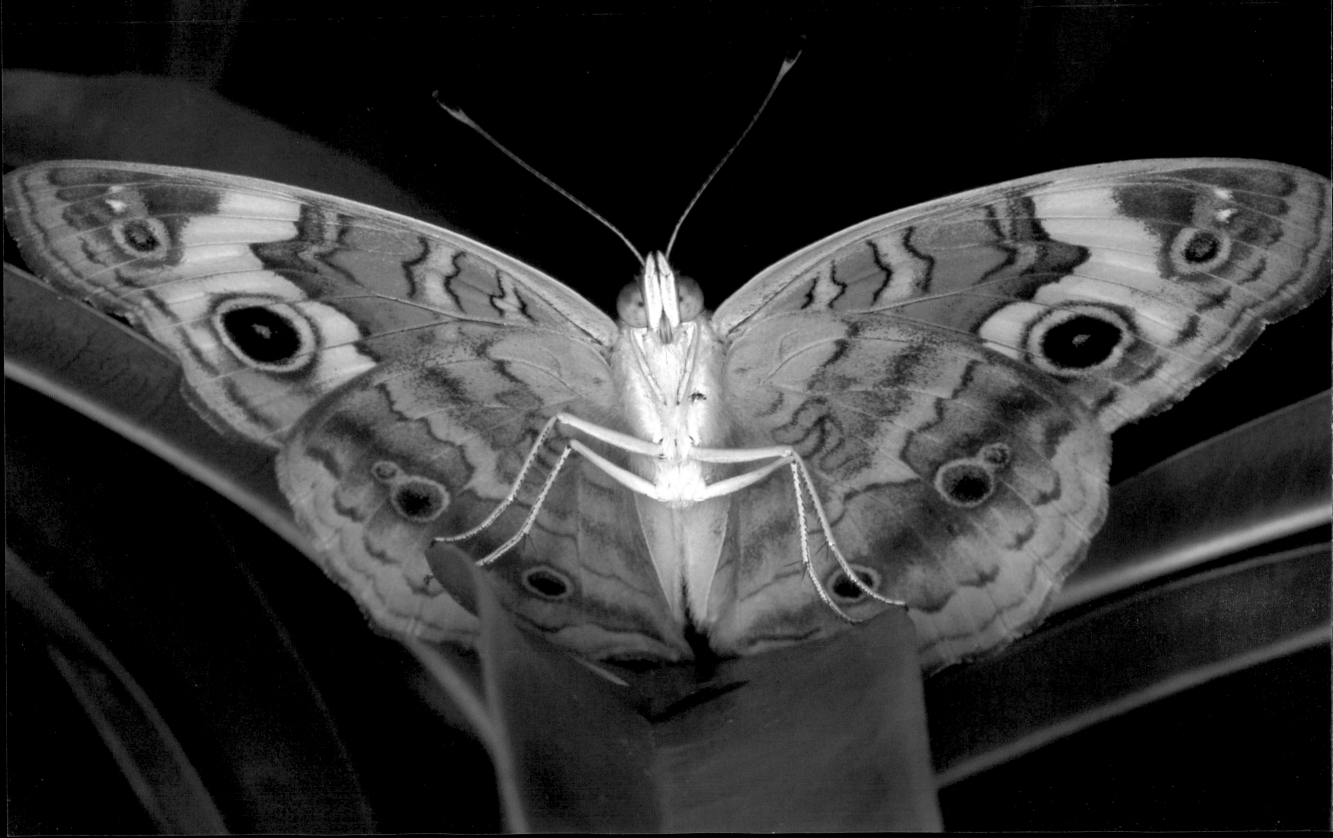

*Precis coenia*
BUCKEYE
RANGE: United States to Mexico,
Cuba, the Bahamas, and Bermuda

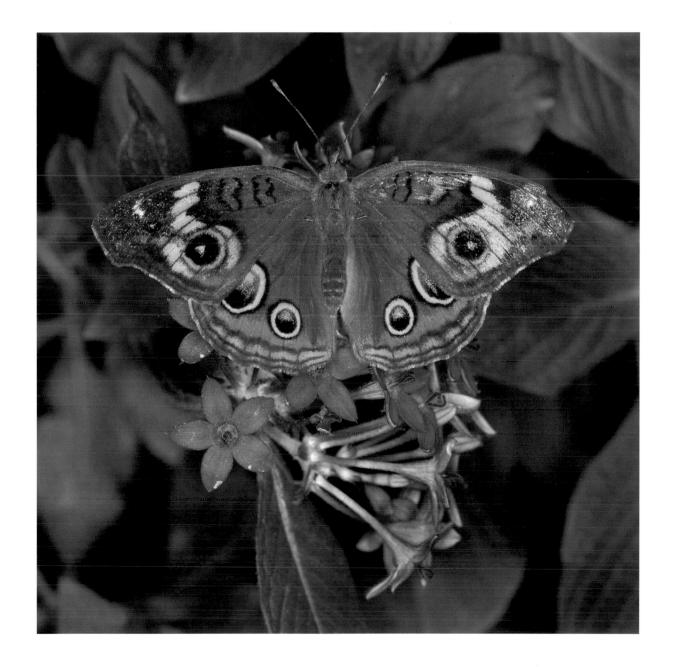

72    *Papilio troilus*
SPICEBUSH SWALLOWTAIL
RANGE: Eastern North America

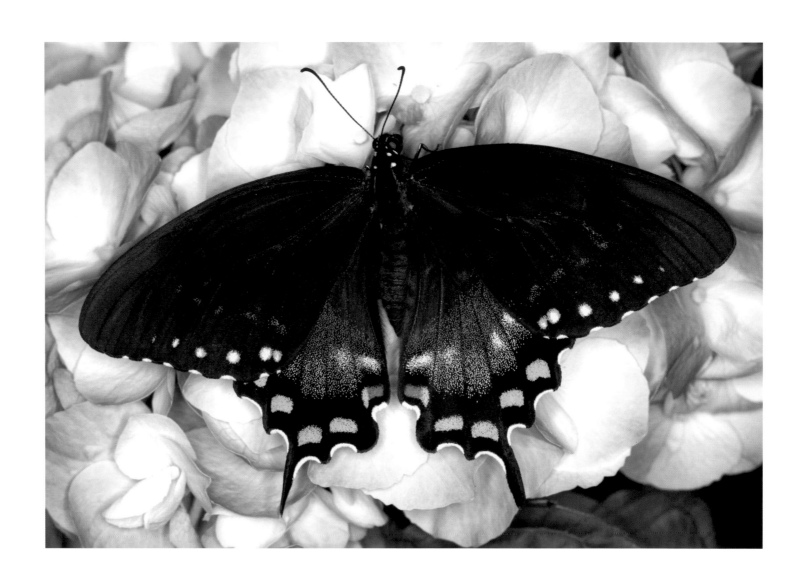

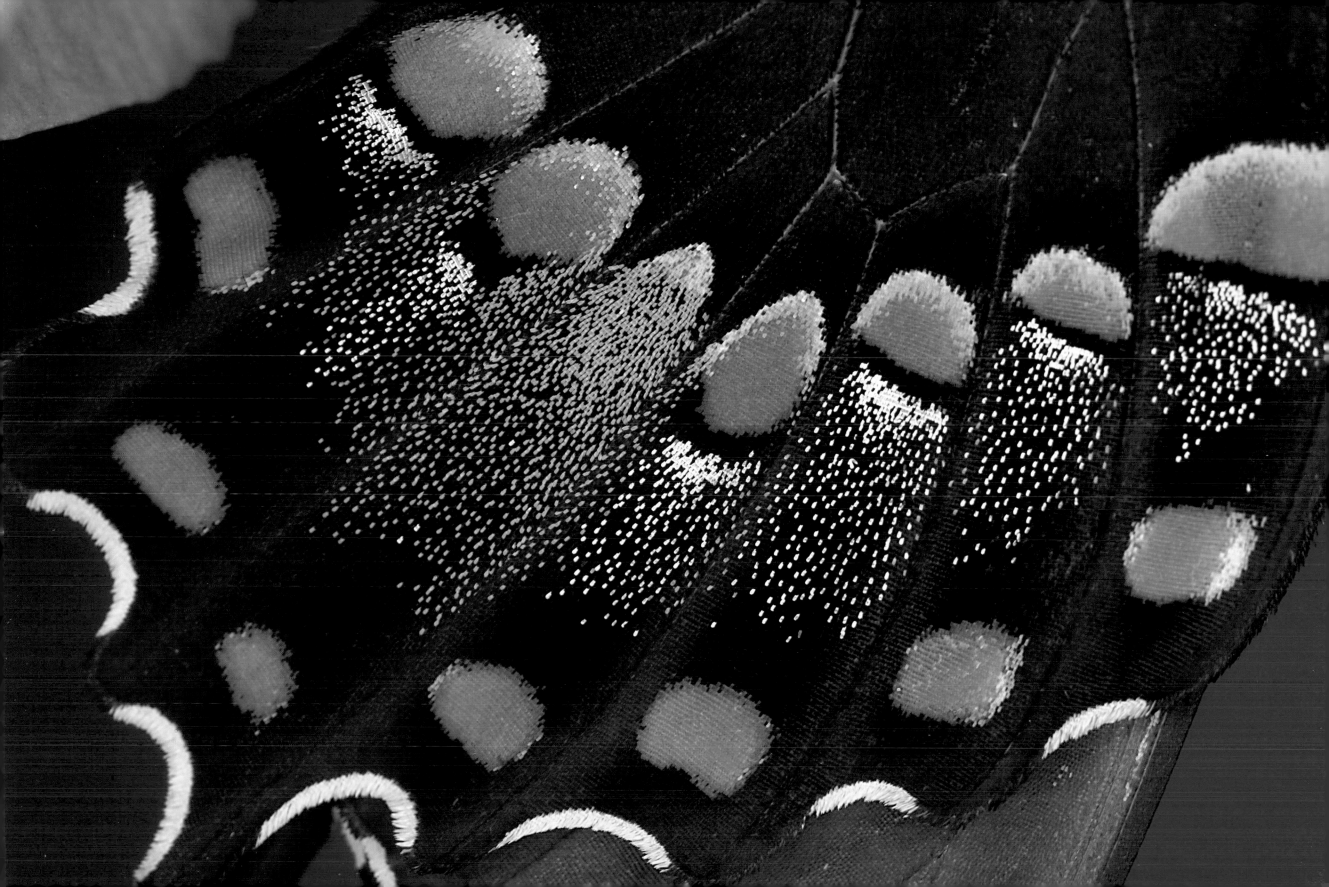

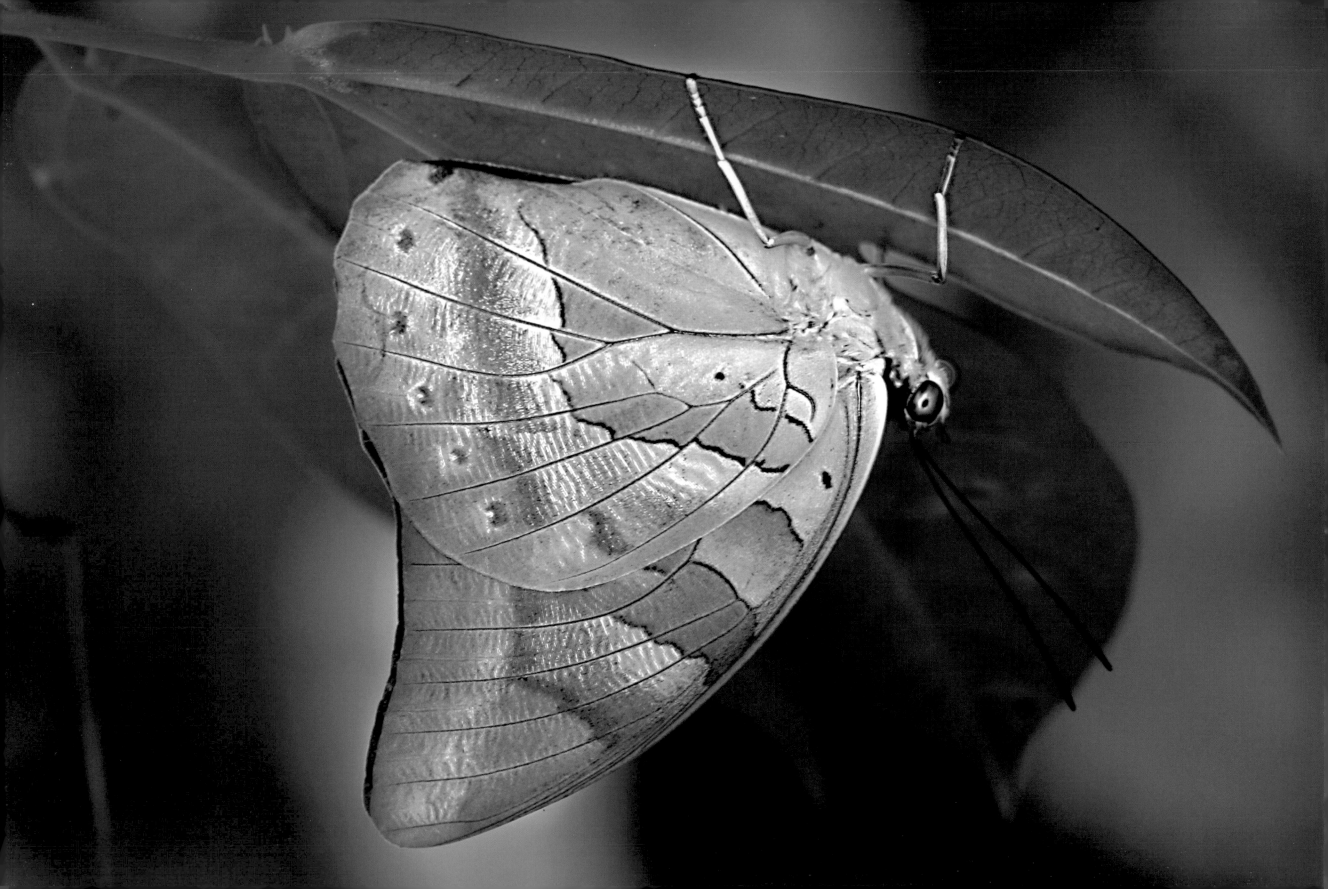

[opposite]
*Archaeoprepona demophon*
KING SHOEMAKER
RANGE: Mexico to Panama

[right]
*Cethosia biblis*
RED LACEWING
RANGE: India to China, Indonesia,
Malaysia, and the Philippines

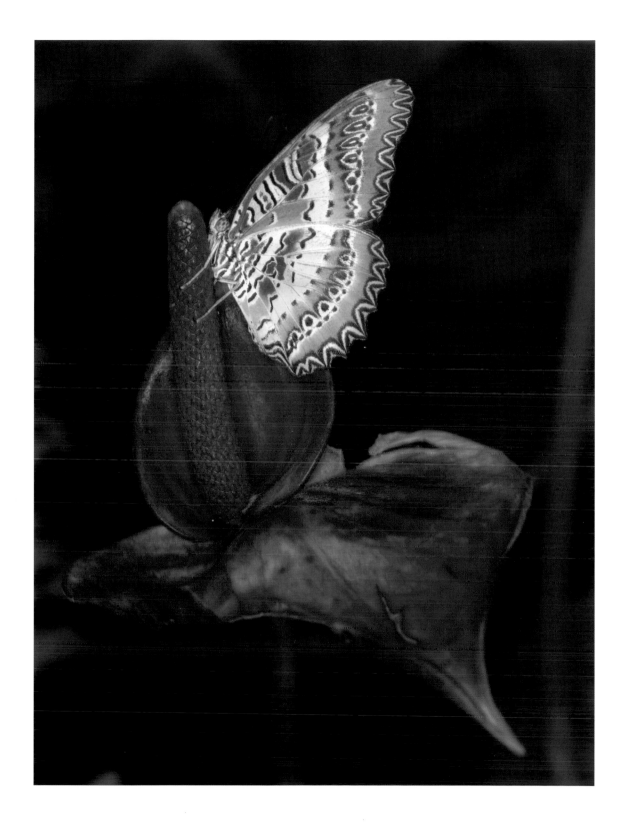

*Tithorea harmonia*
TIGER
RANGE: Mexico to Brazil, and Trinidad

I do not know whether I was then a man dreaming I was a butterfly, or whether I am now a butterfly dreaming I am a man.

—Chuang Tse, philosopher

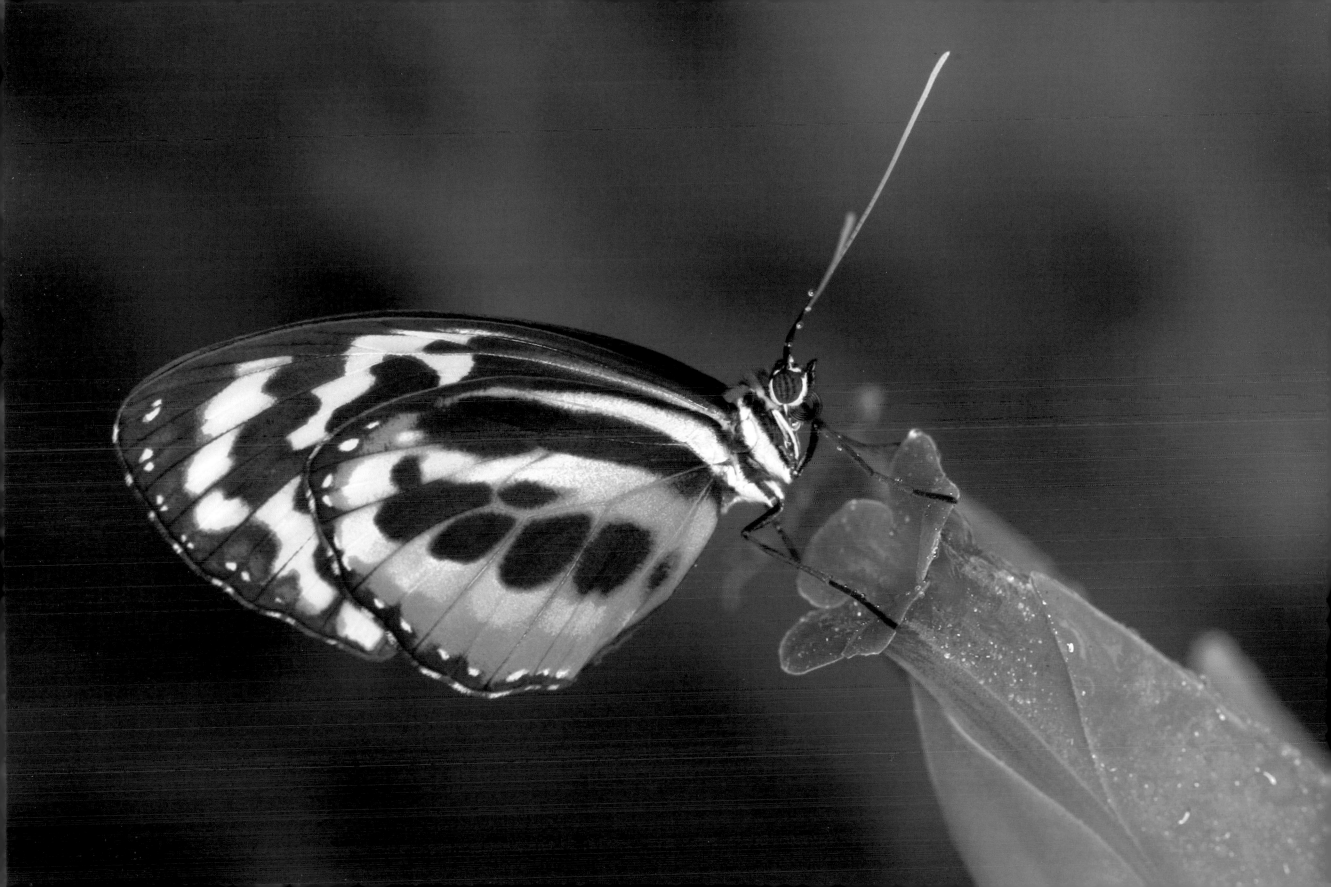

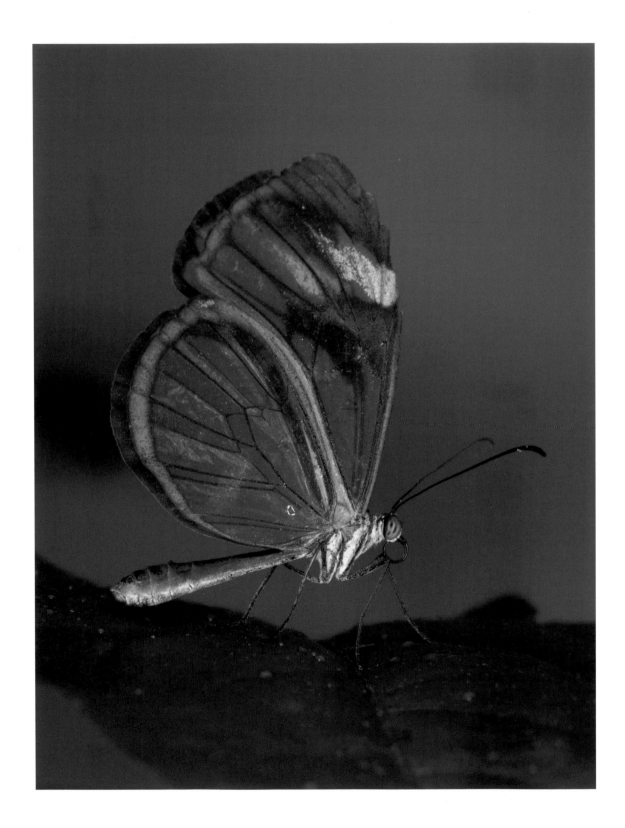

[left]
*Greta oto*
GLASSWING BUTTERFLY
RANGE: Mexico to Panama

[opposite]
*Morpho peleides*
BLUE MORPHO
RANGE: Mexico to Columbia,
Venezuala, and Trinidad

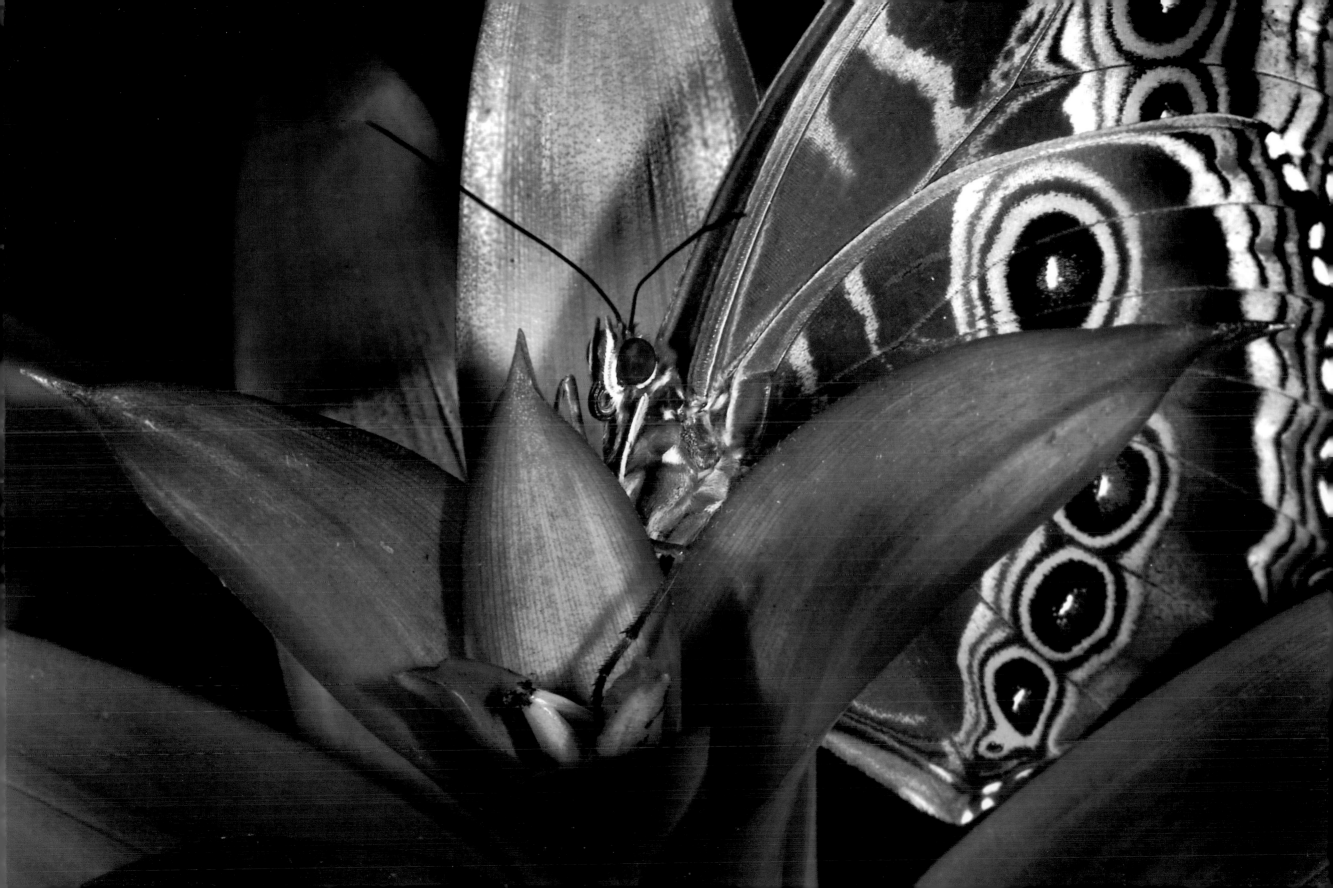

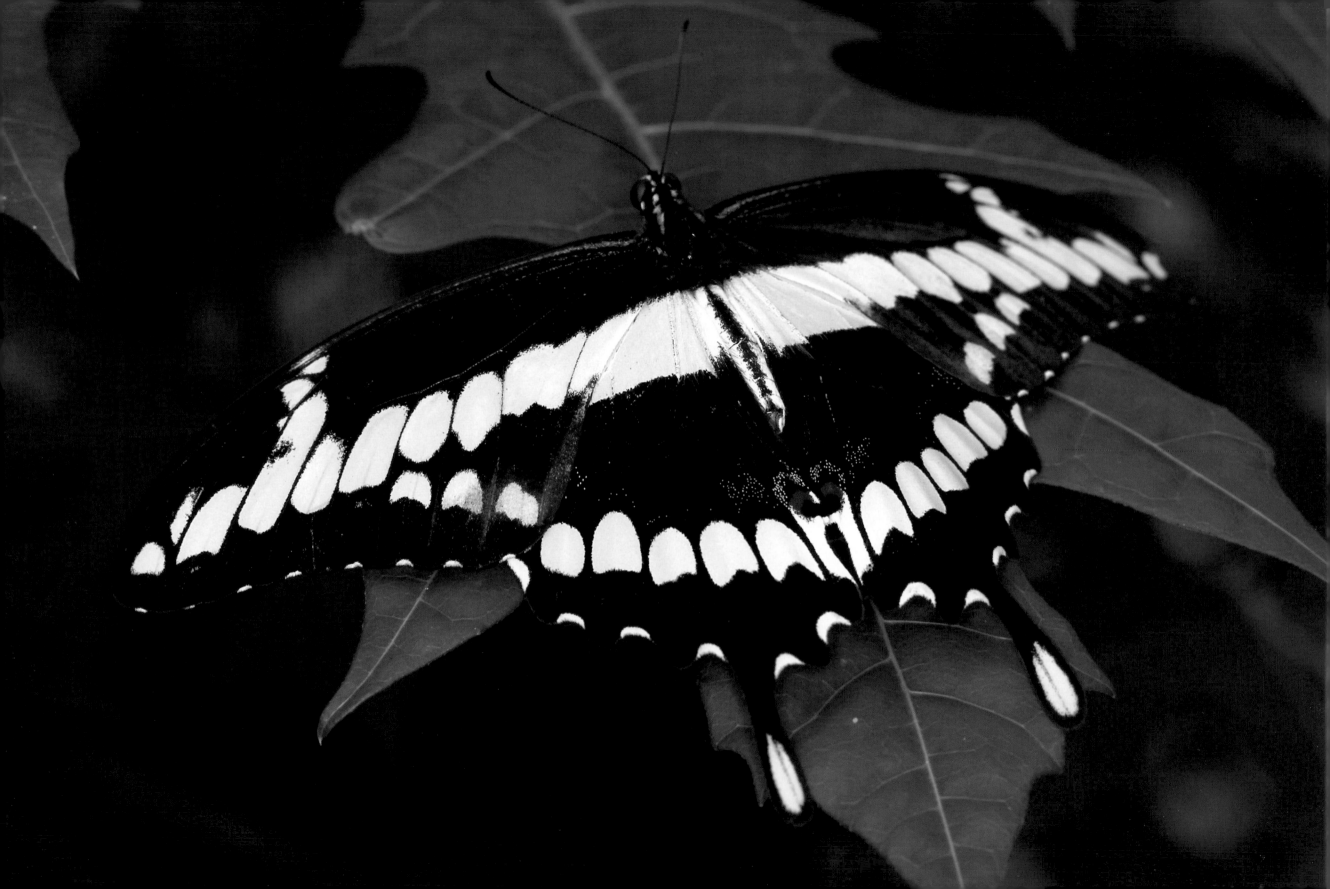

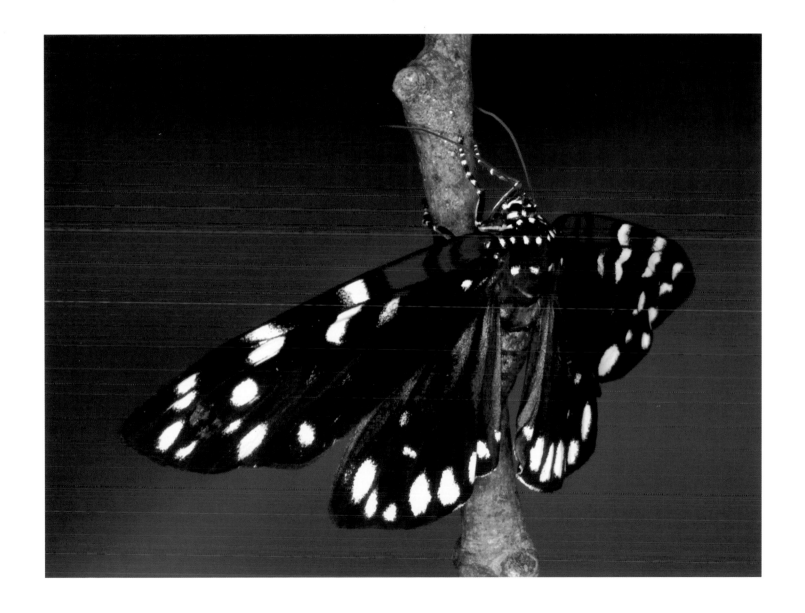

[opposite]
*Papilio cresphontes*
GIANT SWALLOWTAIL
RANGE: Canada to Panama,
and Colombia

[left]
*Composia fidelissima*
FAITHFUL BEAUTY
RANGE: South Florida in the
United States and northern Mexico

82    *Heliconius erato notabilis*
SMALL POSTMAN
RANGE: Ecuador

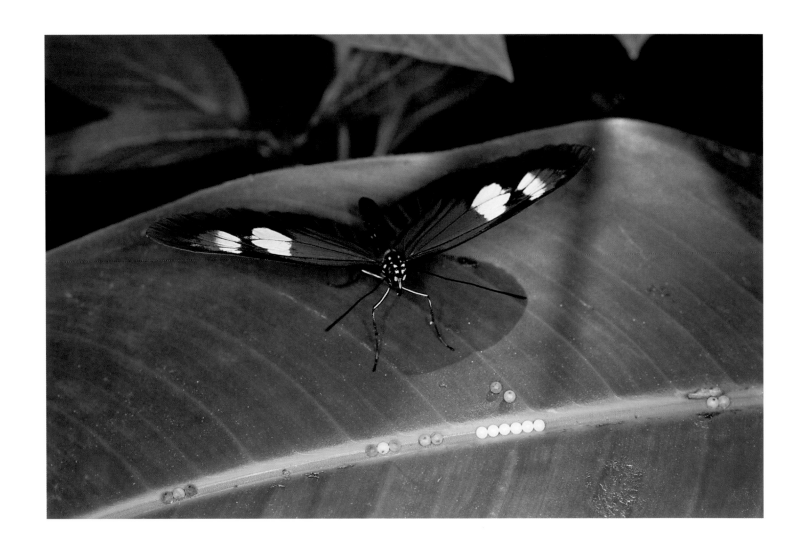

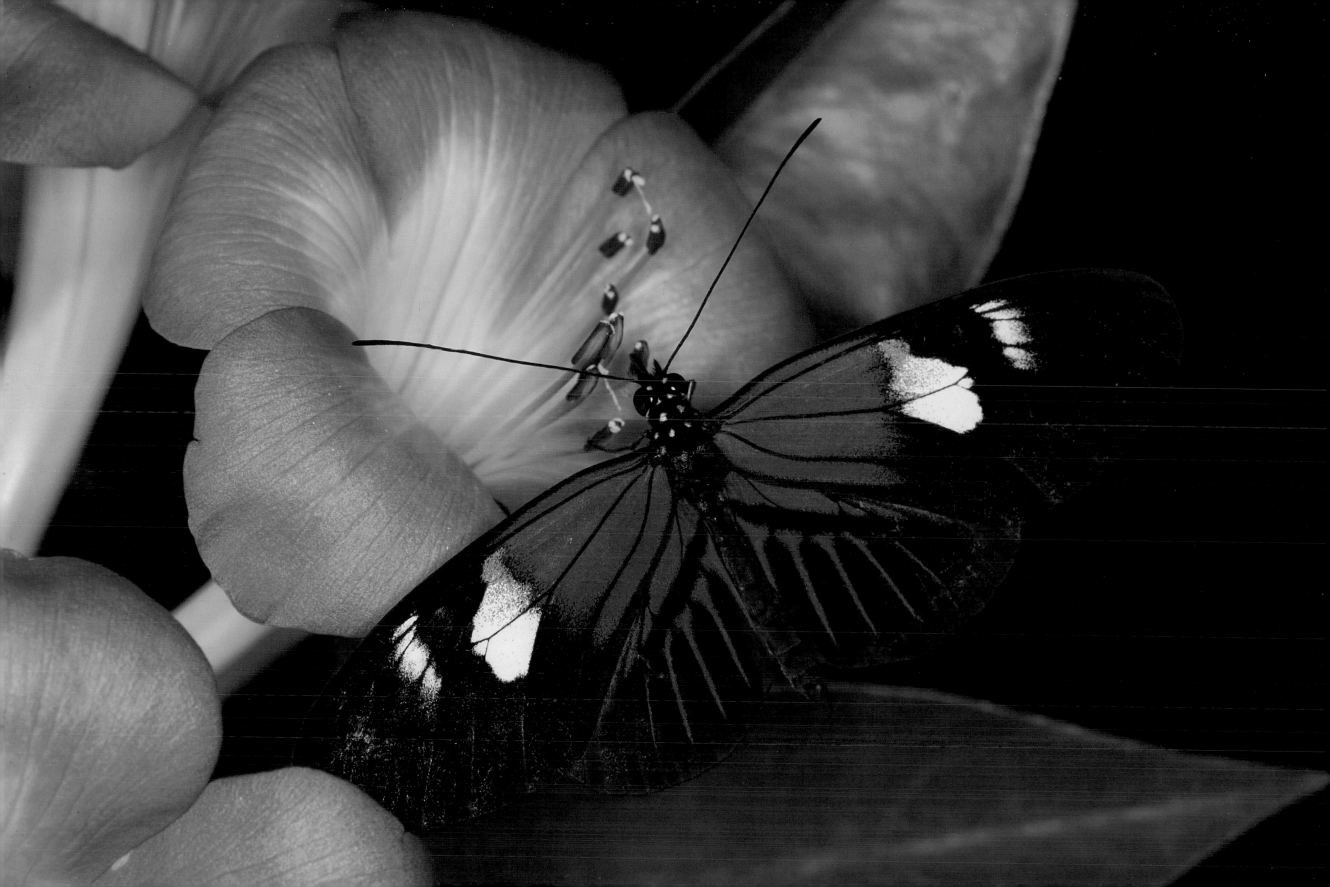

84     *Pieris rape*
CABBAGE WHITE
RANGE: North America to southern
Mexico, Hawaii, Africa, Eurasia, Australia,
Bermuda, Iceland, and New Zealand

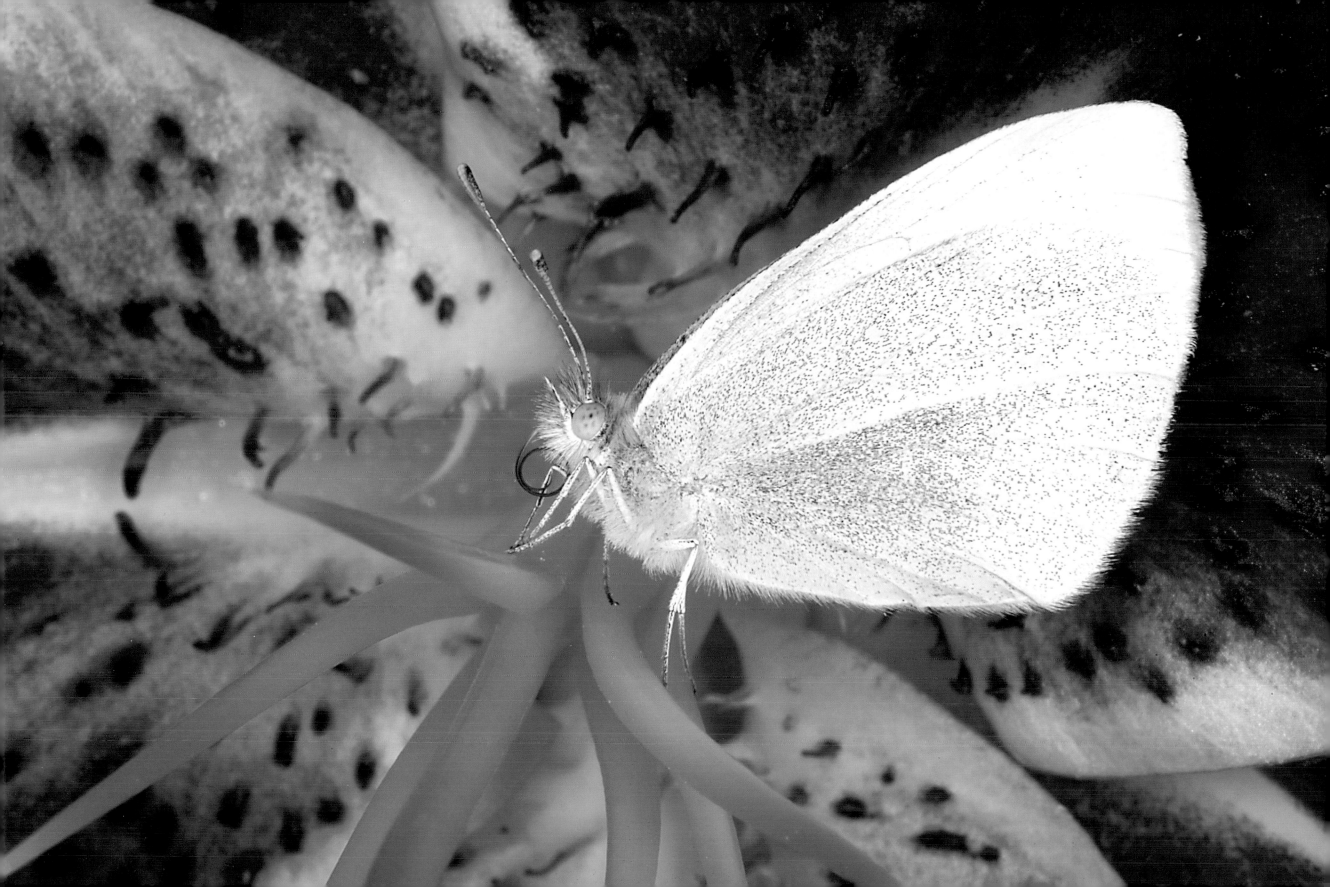

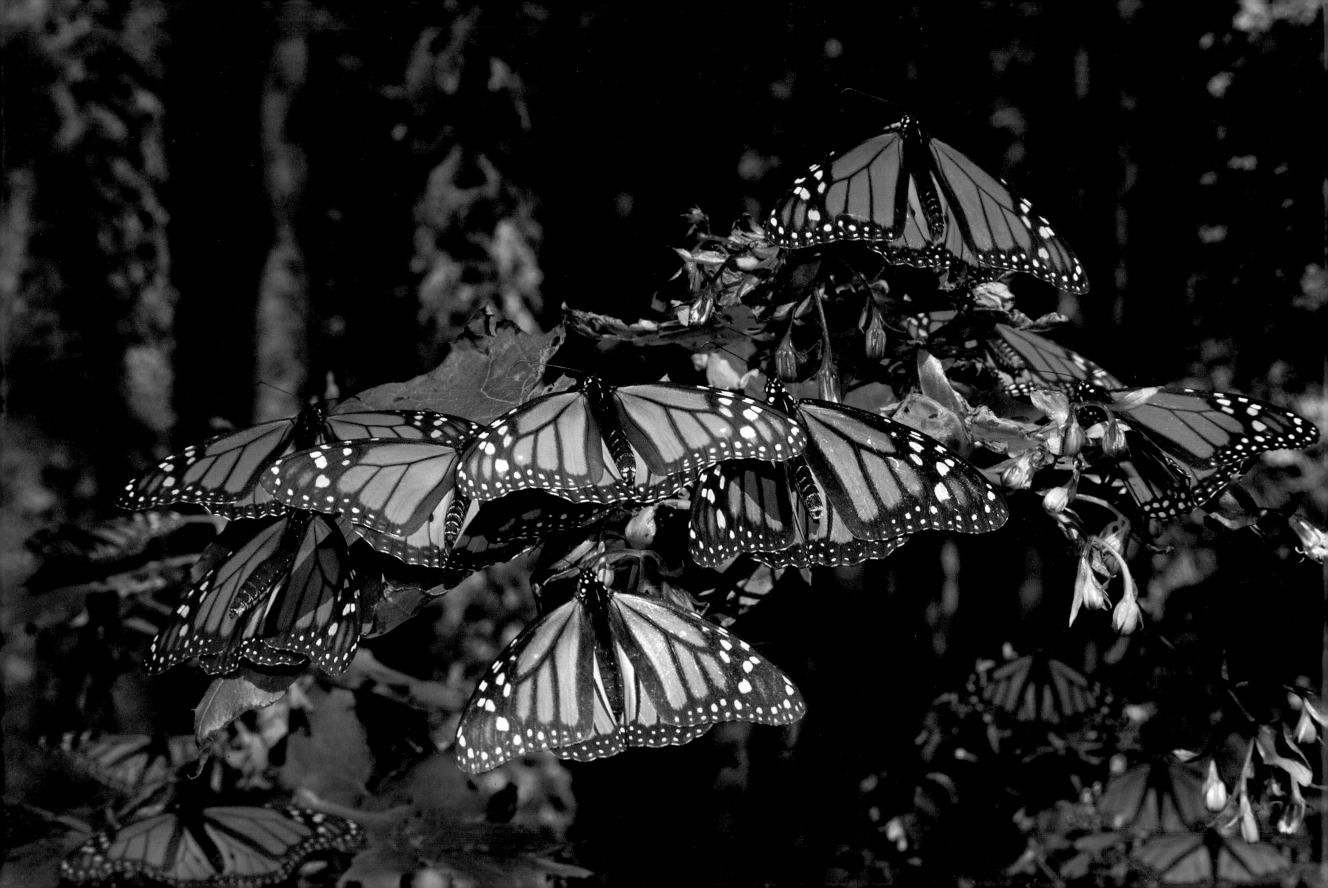

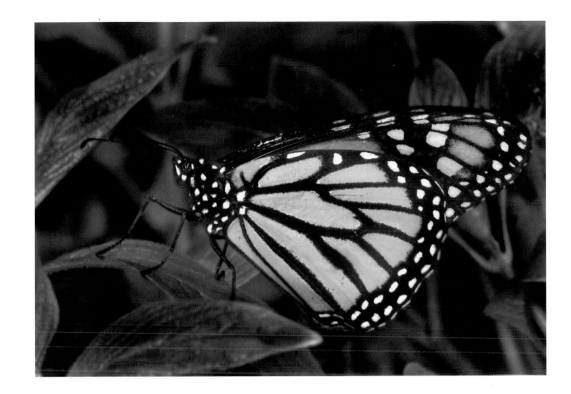

[Pages 86-89]
*Danaus plexippus*
MONARCH
RANGE: The Americas to Hawaii,
Indonesia, and the Canary Islands,
Australia, the Bahamas and the Antilles

## THE MONARCH MIGRATION

### THOMAS C. EMMEL, Ph.D.

Every fall, more than one billion Monarch butterflies travel from Canada and the eastern United States to the mountains of central Mexico, where they remain for 4 1/2 months, before flying north again in March to the southern boundary of the United States. They make this 2,000-mile journey with no man-made compass or hand-held GPS unit, no satellite tracking help, no map—only their tiny insect-sized brain and a staggeringly sensitive and accurate internal navigation system. At their dozen colonies in the high, fir-covered slopes of the Trans Volcanic Range, they have survived as a species for thousands of winters, subjected to fierce windstorms that sweep millions of them from the trees; illegal logging that decimates thousands of firs and leaves the colonies vulnerable to storm damage; and global warming itself, driving them further up a set of finite mountaintops to escape the increasing lowland temperatures in search of their favored hibernation range. To view this unique migratory spectacle in nature is to step back in time and imagine what it was like to see four billion Passenger Pigeons darken the skies, sixty million bison cover the Great Plains, and two million or more wildebeest cover the East African savanna. That is why scientists and naturalists alike are working with utmost effort to save these few remaining Monarch colonies in Mexico from human destruction, and why we need to study them to better understand how the butterfly accomplishes these most remarkable navigational and survival feats in the face of all that nature and man has thrown at them.

*Professor Emmel is director of the McGuire Center for Lepidoptera and Environmental Research at the Florida Museum of Natural History in Gainesville, Florida.*

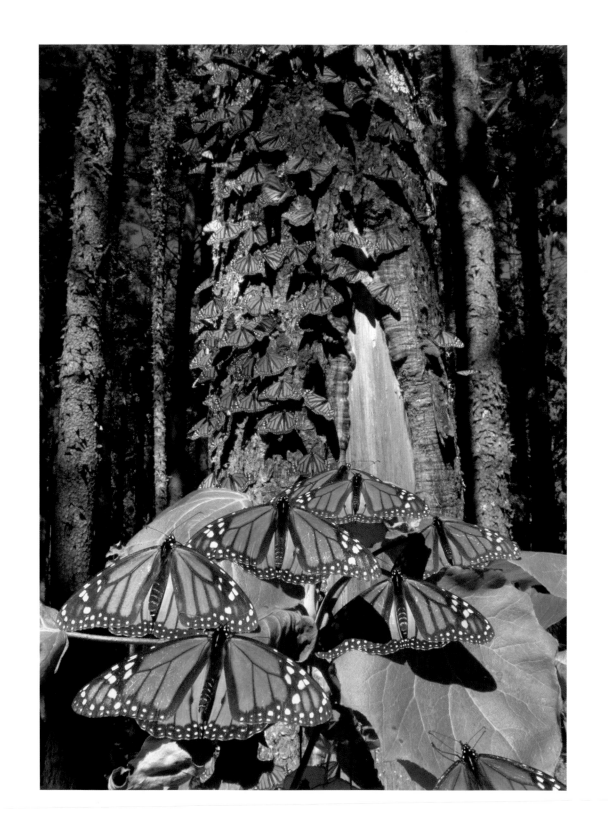

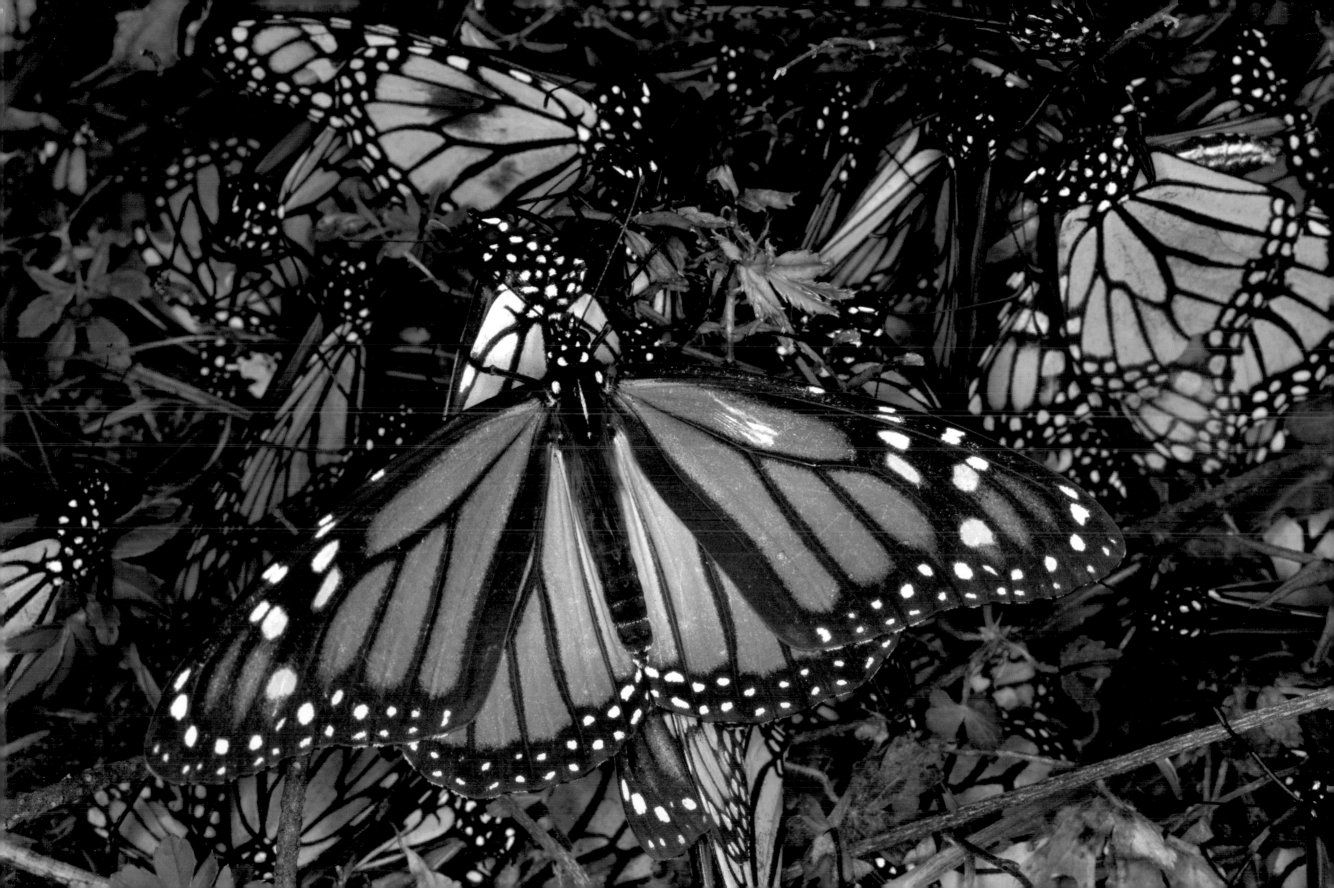

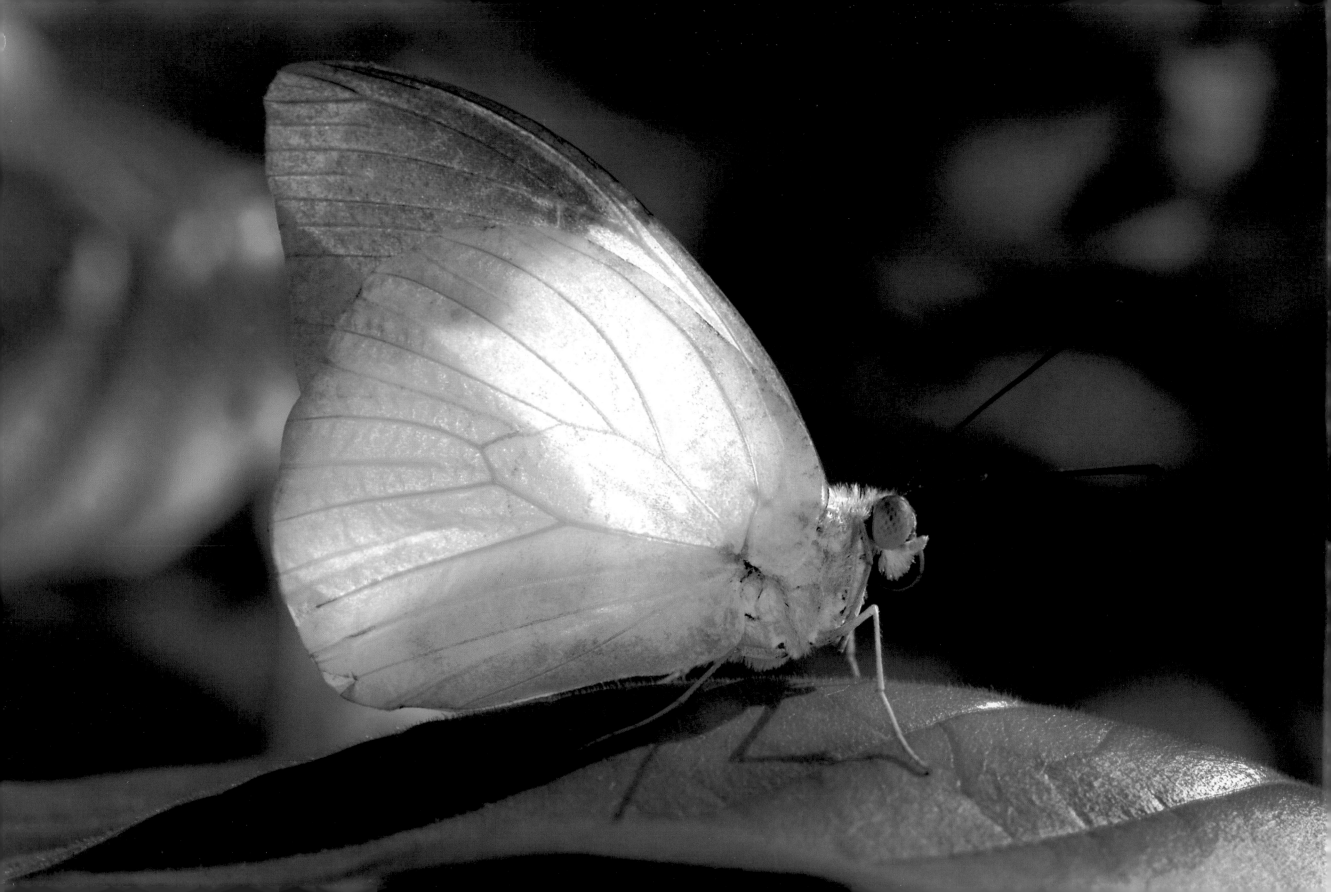

## WHO SPEAKS FOR THE BUTTERFLIES?                    GARY NOEL ROSS, PH.D.

The adage "Home is where the heart is" is often quoted to explain humankind's uncanny ability to successfully occupy virtually the entire surface of our world. But when it comes to the millions of other species of animals that we share the Earth with, the word "home" is far more restrictive. Most creatures have extremely limited abilities to inhabit an environment significantly different from that in which they evolved. Not hunting, not collecting, but *habitat destruction* is the primary reason that so many living things today are being propelled to the brink of extinction. In the long run, it all boils down to this: Do we wish to live in a world devoid of butterflies, creatures that most cultures view as the paragon of the natural world—"flying flowers"—and which the ancient Greeks so esteemed that they bestowed upon them the sacred name "psyche," literally, guardians of the human soul? Of course, such a question will compel us to con-

front the very essence of our humanity, namely our ethics, our compassion, even our spirituality. Make no mistake, our reactions and actions will not be inconsequential; at risk are not only lepidopterans but all of nature—including, I dare say, *Homo sapiens*. In his opus, *Cosmos*, the late acclaimed astronomer Carl Sagan asks: "Who Speaks for Earth?" The question is not open-ended. Sagan counsels of our individual responsibility by admonishing: "We speak for Earth. Our obligation to survive is owed not just to ourselves but also to that Cosmos, ancient and vast, from which we spring."

*Professor Ross is Professor Emeritus at Southern University, Louisiana, Director of Butterfly Festivals (North American Butterfly Association), and Research Associate at the McGuire Center for Lepidoptera and Environmental Research at the Florida Museum of Natural History.*

# ADDITIONAL NOTES

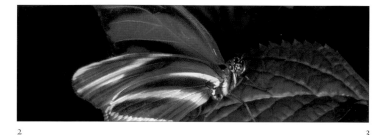

Cover | 1     2 | 3

*Pieris rape*
CABBAGE WHITE
RANGE: North America to South Mexico, Hawaii, Africa, Eurasia, Australia, Bermuda, Iceland, and New Zealand
This little Eurasian beauty was accidentally introduced to Quebec, Canada, around 1860. *Pieris rape* is so resilient that it has since spread throughout all of North America up to the Canadian Taiga.

*Dryadula phaetusa*
BANDED ORANGE
RANGE: Mexico south to Paraguay
This brilliantly colored butterfly is the only occupant of the genus *Dryadula*. Like some other heliconians, the *Dryadula phaetusa* is sometimes found roosting gregariously at night.

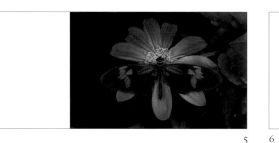

    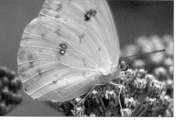

4 | 5    6 | 7    8 | 9

*Heliconius melpomene*
THE POSTMAN
RANGE: Central America to southern Brazil
*Heliconius* butterflies are considered to be the brains in the world of butterflies. They use color associations and recognizable landmarks to help locate nectar sources and host plants on which to lay their eggs.

*Phoebis philea*
ORANGE-BARRED SULPHUR
RANGE: Florida, in the United States, Central and South America
The chrysalis may appear to be quietly at rest on the outside. But on the inside, the tissues of the larva are being broken down to be reconstructed into the adult butterfly. This process is termed metamorphosis.

Upon emerging from the pupa, the adult butterfly begins to pump fluids into the many wing veins, in order to stretch the crumpled wings into the final shape and size. When initially stretched, the wings are as soft as silk fabric and may take a couple of hours to dry.

The brilliant yellow *Phoebis philea* is very easily spotted when in flight. However, in seeking out a place to rest, it targets yellowing foliage and settles on the underside, where it is perfectly camouflaged.

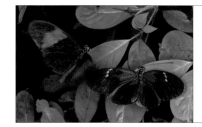 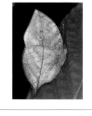

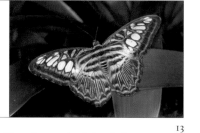 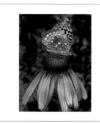

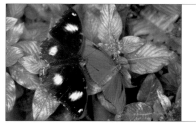 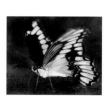

10 | 11    12 | 13    14 | 15

Male *Heliconius* butterflies (left) have the ability to hover over the female during courtship, in addition to flying forward and backward in small loops.

Many butterflies use coloration to blend in with dried leaves. The *Kallima paralekta* (right) goes one step further by mimicking the leaf, including the venation.

Females of the *Speyeria cybele* (left) tend to randomly lay their eggs on almost any surface near the host plant, such as stones or the leaves of neighboring fauna.

Female brush-footed butterflies, such as the *Parthenos sylvia* (right), use their first pair of legs to taste the host plant when laying eggs. Called *drumming*, she rapidly taps the surface of the leaf with each leg.

Once a butterfly emerges from its chrysalis and dries its wings, it will never grow any bigger. Adult butterflies vary in size, with wingspans from 3/4 to 11 inches.

Many butterflies, such as the *Papilio cresphontes* (right), engage in an activity called *puddling*. Although this activity draws them to moist areas on the ground, they are in fact drinking in order to obtain salts and minerals, not due to thirst.

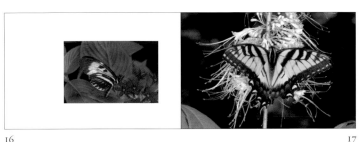

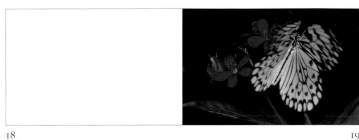

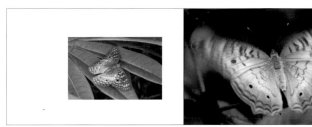

16 17

*Heliconius melpomenes* (left), like all butterflies, are important pollinators for many plants. As adults innocently sip nectar from a flower, they also carry pollen from flower to flower.

Named for its striped wings, this is one of a few types of Tiger Swallowtails (right). Other species of Tiger Swallowtails may have up to six tails.

18 19

Like all butterflies, *Idea leuconoe* possess two filaments that are joined to appear as one, called a *proboscis*. When feeding on nectar from flowers, the butterfly uncoils the proboscis from under its head in order to drink its liquid diet.

20 21

Certain species of butterflies such as *Anartia jartophae* (left) use the sun's rays to raise their body temperature to an ideal 32°C. They often bask with their wings open for maximum exposure.

The colors of many butterflies are derived from chemical pigments within the thousands of scales on their wings. These scales absorb certain wavelengths of light, which, when reflected back to us, appear as solid colors.

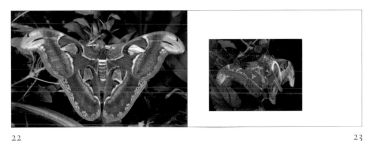

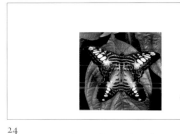

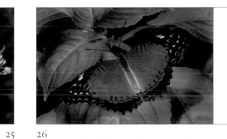

22 23 24 25 26 27

The tips of the Atlas Moth's forewings resemble the head of a snake

Some butterflies within the same species display different wing colors or patterns in different areas of the world. For example, Clippers (left) from Malaysia are blue, whereas those from the Philippines are brown.

The palatable beauty of the Spicebush Swallowtail (right) mimics a distasteful relative, the Pipevine Swallowtail, to gain protection from predators.

Like all butterflies, the Red Lacewing sees with a pair of compound eyes, each of which is composed of several thousand visual elements called *ommatidia*. Though they do not see in sharp focus, they are very sensitive to movement and use their antennae to find food, mates, and host plants.

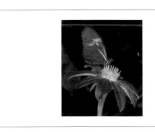

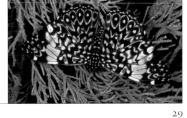

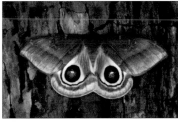

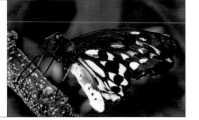

28 29 30 31 32 33

*Heliconius* butterflies (left) are extremely long lived as adults, known to live up to nine months in a controlled environment.

*Hamadryas* butterflies (right) receive their "Cracker" name due to their unusual ability to produce crackling noises when they encounter one another while in flight.

While at rest, the forewings of the *Automeris io* (left) completely cover its hindwings, causing it to look like dried foliage. If disturbed, it quickly moves its forewings forward to reveal its eyespots to startle predators.

The 88 Butterfly (right) is named for the amazing numerical pattern on the underside of the hindwing.

The Cruiser Butterfly (left) is extremely sexually dimorphic, and so the male and female may easily be distinguished even in flight : males are a rich shade of orange; females appear gray and white.

Female *Ornithoptera* (right) are generally noticeably larger than their male counterparts with wingspans up to eleven inches. The smaller males are usually more brilliantly colored, with iridescent gold or green wings.

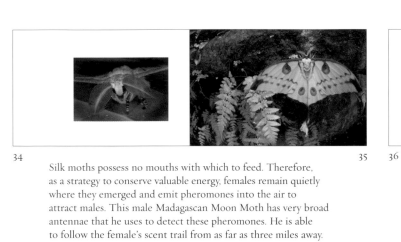

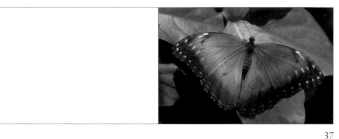

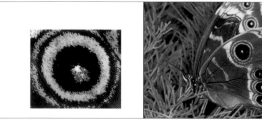

34

35

36

37

38

39

94

Silk moths possess no mouths with which to feed. Therefore, as a strategy to conserve valuable energy, females remain quietly where they emerged and emit pheromones into the air to attract males. This male Madagascan Moon Moth has very broad antennae that he uses to detect these pheromones. He is able to follow the female's scent trail from as far as three miles away.

Appropriately named *Morpho*, which means "beautiful" or "well made," this group is one of the most dazzling. Many species exhibit large expanses of brilliant iridescent blue on the upper side of the wings.

The delicate wings of the Blue Morpho are waterproof. As water settles on the wings, it gathers into beads that eventually roll right off.

The blue topside and brown underside of the Blue Morpho's wings create a strobe effect as it flies, making it difficult for predators to follow its flight paths.

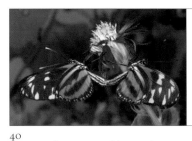

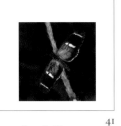

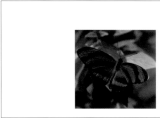

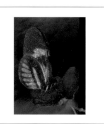

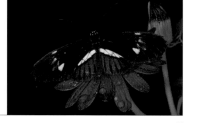

40

41

42

43

44

45

After a successful courtship, a pair of Isabella butterflies (left) may copulate for up to several hours while the male transfers his spermatophore to the female.

When laying eggs, a *Heliconius sara* (right) may be joined by one or more females, ultimately leaving a large group of eggs on the same location of the host plant.

The Banded Orange caterpillar (left) is armed with multiple irritant spines in order to deter predators.

The brilliant green shade of the Banded Peacock's wings (right) is created by a phenomenon known as *interference* or *structural color*. Depending on your angle of view, the butterfly may appear copper, green, or even blue.

While feeding, *Heliconius* adults bob their heads up and down in order to collect and build up a pollen load on their proboscis. Amino acids extracted from the pollen are the source of this genus's longevity.

*Heliconius* butterflies achieve their distasteful nature while in the caterpillar stage, when they incorporate the toxic compounds contained within the leaves of the host plant.

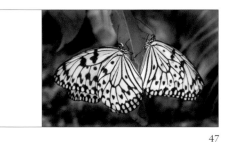

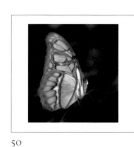

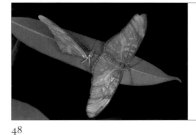

46

47

48

49

50

51

Male Large Tree Nymphs require chemicals called *pyrrolizidine alkaloids* from specific types of flowers, which they use to synthesize pheromones to successfully court females.

Males of many species, including *Dryas iulia,* patrol areas looking for females. If unimpressed with her suitor, a female may raise her abdomen out of reach of the pursuing male.

The extraordinary *Siproeta stelenes* not only feed on nectar, but also on fruit, carrion, and even animal dung.

A Malachite's defense against predators is camouflage. However, in some countries, it employs a strategy of mimicry in order to look like another butterfly (*Philaethria dido*) which is distasteful to predators.

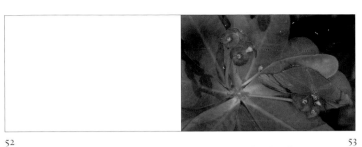

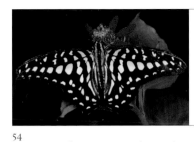

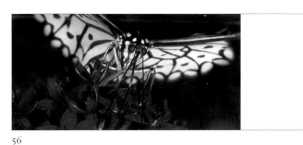

52     53     54     55     56     57

When female Julias find passion vine, they will often lay their eggs at the end of the tendrils or even on the neighboring vegetation that supports the vine.

*Graphium agamemnon* has a relatively short life cycle, developing from egg to adult in 33 to 36 days.

The Tailed Jay quivers its wings rapidly while sipping nectar from flowers. With seemingly no time to waste, this fast, strong flyer dashes from flower to flower as if in a feeding frenzy.

The male Large Tree Nymph extends a pair of hair pencils from the end of his abdomen when courting a female to entice her with his pheromones.

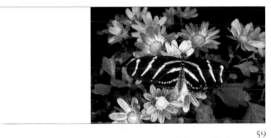

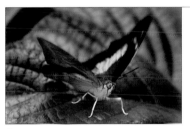

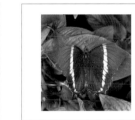

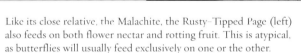

58     59     60     61     62     63

This *Heliconius* species demonstrates an unwavering ability to find the same roosting locale night after night. Gathering in numbers from just a few to a few dozen, they may continue to use the same spot for weeks or months.

Males of the *Archaeoprepona demophon* species (left) perch on tree trunks or leaves facing downwards and vigorously chase any passing butterflies, only to return to the same waiting spot.

With a wingspan of up to four inches, the Great Orange-Tip (right) is the largest of all Pierids in Asia.

Like its close relative, the Malachite, the Rusty-Tipped Page (left) also feeds on both flower nectar and rotting fruit. This is atypical, as butterflies will usually feed exclusively on one or the other.

The Grey Pansy (right), along with many other butterfly species, varies slightly according to season. In the dry season, the ocelli may be absent in the post-discal area when compared to the wet season form.

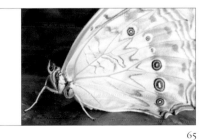

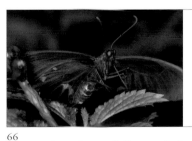

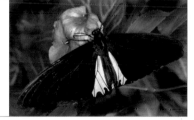

64     65     66     67     68     69

The amazing White Morpho never visits flowers for nectar. It feeds exclusively on ripe or rotting fruit juices.

The Pink Rose (left) generally favors a rain forest habitat. But as destruction of these precious areas continues, this beauty is also adapting to open areas.

As with all butterflies, this Common Rose (right) is equipped with sensory structures on all six legs that allow it to taste with its feet.

The Autumn Leaf (left) is one of many brush-footed butterflies. Though they appear to have only four legs, they actually have six. The hidden pair is much smaller and pulled tightly against the body just behind the head and is never used for walking.

Swallowtail butterflies, such as this Common Birdwing (right), use all six legs for walking.

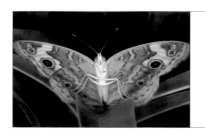
70

71

Directly between the eyes of the *Precis coenia* is a pair of palpi that are widely thought to be used for cleaning the eyes, as they are often seen brushing across the eyes while feeding or at rest.

72

73

The tail of the Spicebush Swallowtail is often designed to confuse predators, giving the impression the butterfly has two heads. If the predator attacks the tail end, the wings easily tear, giving the butterfly time to escape.

74
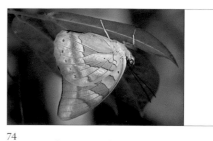

75

*Archaeopreponas* (left) are among some of the fastest flying butterflies in the Neotropics.

The intricately patterned Red Lacewing (right) advertises its toxicity to would be predators with brilliant colors and patterns.

76
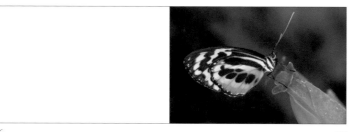
77

Male Tiger Butterflies have hair-like scales along the costal area of the hindwing, called *androconial scales*. During courtship, these scales are exposed in hopes of enticing a female to copulate.

78

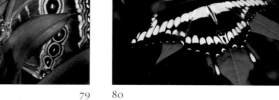
79

Dispelling the myth that butterflies cannot live if the scales are removed from their wings, the Glasswing (left) is born with completely transparent areas across most of its wings.

The underside of this brilliant Blue Morpho (right) has multiple ocelli or eyespots. These ocelli may momentarily startle predators, giving the butterfly time to escape.

80

81

The caterpillar of the *Papilio cresphontes* (left) is known to mimic bird droppings and perch on the top of a leaf to avoid predators.

The Faithful Beauty Moth (right) uses an unusual defense strategy when startled by predators. It gives off a bubbly liquid from its thorax, which is both noxious and distasteful.

82
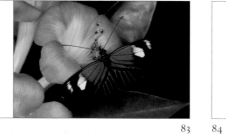
83

Small Postman females are sought out by males while they are developing in the chrysalis. Many males may perch on the female's chrysalis, waiting days for her transformation to be complete. One male will eventually mate with her shortly before she emerges.

84
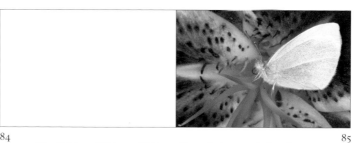
85

The Cabbage White or Cabbage Butterfly is an agricultural pest which gets its name from one of the many host plants which the caterpillar uses: cabbage. The larva also favors many other well-known plants such as broccoli, collards, and mustards.

86
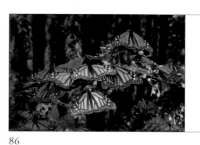
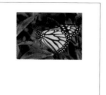
87

Millions of Monarch butterflies gather at the same migratory sites in Mexico for the winter, year after year.

Migratory Monarchs live for about six months while non-migratory Monarchs live only six weeks.

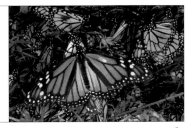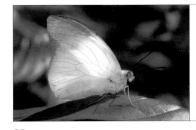

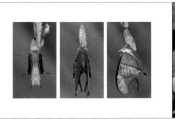

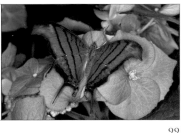

88                                             89     90                                        91     98                           99

While wintering in Mexico, Monarchs survive on stored body fat, as there is a distinct absence of flowers at their wintering sites.

The extreme numbers of roosting butterflies sometimes cause the limbs of the fir trees they perch on to break.

The Great Orange-Tip is one of the fastest flying Pierids, and is capable of traveling great distances in a day. Its erratic flight patterns—often suddenly changing direction for no apparent reason—may help avoid predators.

*Marpesia petreus*
RUDDY DAGGERWING
RANGE: Texas and south Florida in the United States, Mexico to Brazil, Puerto Rico, and the lesser Antilles
Armed with multiple spines, the Ruddy Daggerwing caterpillar and chrysalis appears to be menacing (far left). However, these spines possess no ability to inflict any sting for self-defense.

The brilliant orange color on the dorsal side of the swift flying Ruddy Daggerwing (right) is prominently displayed when feeding. However, while at rest with closed wings, it is cleverly camouflaged as a dried leaf.

97

## BEHIND THE SCENES

RICK SAMMON

The digital SLR system and image-editing software programs I used made this book uniquely possible. After shooting a photograph, I could immediately view the image on my camera's LCD monitor and make exposure and lighting adjustments accordingly. That was of the utmost importance, due to subject movement, changing lighting conditions, and the reflectivity of some of the subjects.

I had the highest standards for image quality and detail; I wanted to capture every scale on a butterfly's wings. That was achievable with my Canon EOS 1Ds digital SLR, with its 11 megapixel image sensor, and my ultra-sharp Canon 50mm and 100mm lenses (which provided just enough working distance so I did not disturb the butterflies). To light my subjects, in virtually all of the photographs in this book, I used the Canon Ring Lite MR-14EX.

Shooting fleeting butterflies in the field was a challenge, especially when it came to choosing the backdrop. In Adobe Photoshop CS, I darkened and softened the background in some pictures to make the subject more prominent—a technique similar to those used by traditional darkroom artists for many years. To enhance the sharpness of low-light images, I used a Photoshop Plug-in called nik Sharpener Pro! from nik multimedia.

If you are interested in learning more about close-up photography, I have a lesson posted on the Canon Digital Learning Center at photoworkshop.com.

If you are looking for a challenging, fun, and rewarding photography adventure, I highly encourage you to take your own pictures of flying flowers—you won't be disappointed.

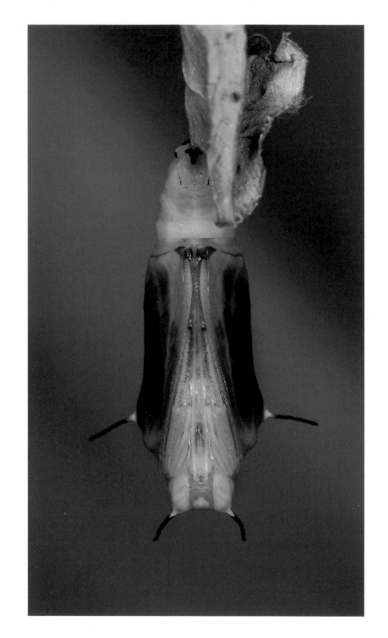
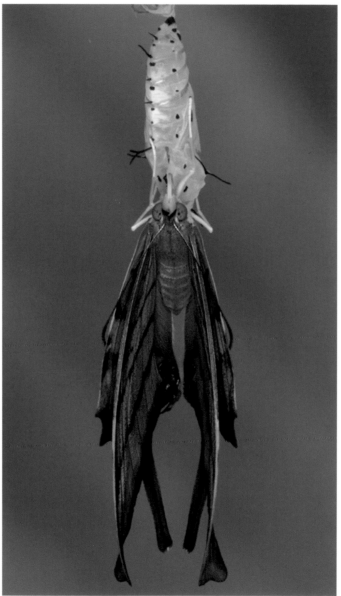
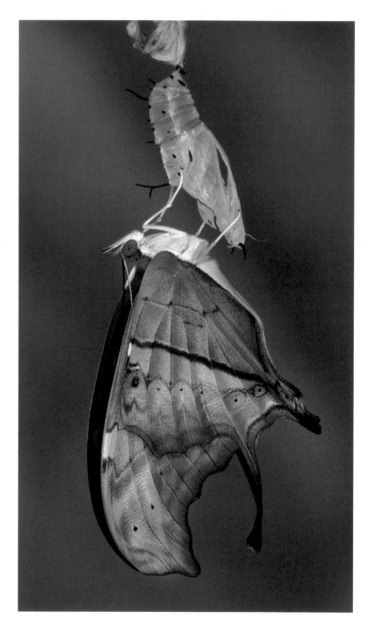

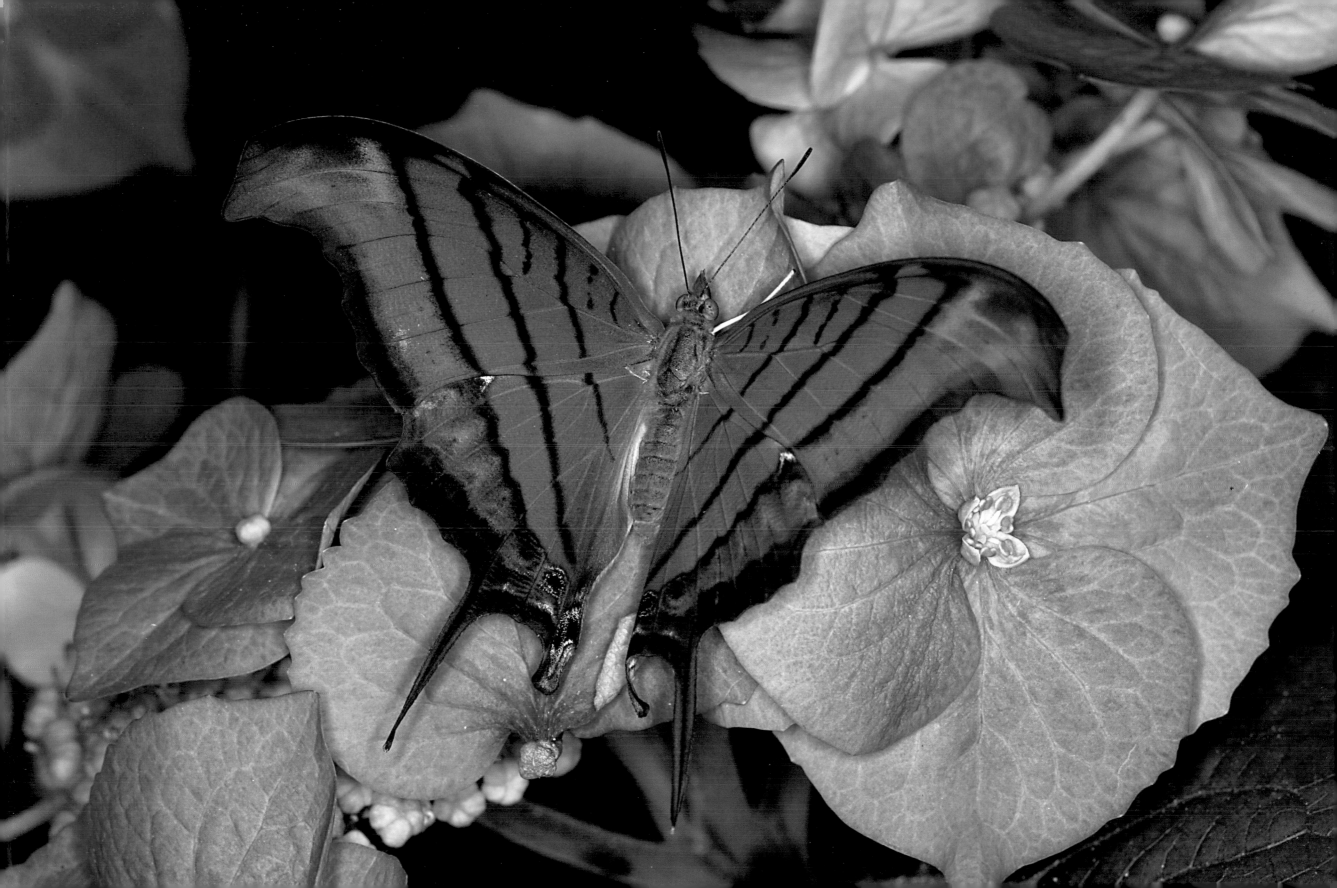

Published in 2004 by Welcome Books®
An imprint of Welcome Enterprises, Inc.
6 West 18th Street
New York, NY 10011
(212) 989-3200; Fax (212) 989-3205
www.welcomebooks.com

*Publisher*: Lena Tabori
*Project Director*: Katrina Fried
*Designer*: Gregory Wakabayashi

Distributed to the trade in the U.S. and Canada by
Andrews McMeel Distribution Services
U.S. Order Department and Customer Service Toll-free: (800) 943-9839
U.S. Orders-only Fax: (800) 943-9831
PUBNET S&S San Number: 200-2442
Canada Orders Toll-free: (800) 268-3216
Canada Order-only Fax: (888) 849-8151

Library of Congress Cataloging-in-Publication Data on file

ISBN 1-932183-27-2

Printed in China

First Edition

10 9 8 7 6 5 4 3 2 1

To purchase original prints by Mr. Sammon, please e-mail rick@ricksammon.com.
For further information about Rick Sammon's books and photography, please visit his website at
www.ricksammon.com.

## ACKNOWLEDGMENTS

These are the wonderful people and companies whose help and contributions
made this project a success:

For her faith in *Flying Flowers*—Lena Tabori

For transforming my images and words into a book—
Katrina Fried and Gregory Wakabayashi

My friend and personal butterfly expert—Alan Chin Lee

Butterfly lovers—Ron Boender and his dedicated staff at Butterfly World

For his many books on butterflies—Dr. Thomas C. Emmel, director of the McGuire
Center for Lepidoptera Research in Gainesville, Florida

For his countless articles on butterflies—Dr. Gary Ross, Research Associate for the
McGuire Center for Lepidoptera and Environmental Research, Gainesville, Florida

Expert butterfly finders and photography assistants—Susan and Marco Sammon
(Susan was especially helpful with the transformation sequence shots.)

Friends and supporters of my work—
Barbara Bordnick, author of *Searchings* and *Searchings II*, who introduced me to Welcome
Books; Tanya Chaung and Mike Wong, SanDisk; Dean Collins, Software Cinema;
Dave Metz, and all my friends at Canon U.S.A., Inc.; Samuel J. Trophia and George L.
Fernandez, The Key West Butterfly and Nature Conservatory; Adam Rackoff, Apple Store
and Theatre in SoHo, New York; Addy Roff and Gwyn Weisberg, Adobe Systems, Inc.;
Jim Heiser, Apple Computer, Inc.; Ed Sanchez and Mike Slater, nik multimedia;
George Schaub, *eDigital Photo* and *Shutterbug* magazines; Wes Pitts, Rob Sheppard, and
Steve Werner, *Outdoor Photographer* and *PC Photo* magazines; my friends at the North
American Nature Photography Association; my dad, Robert M. Sammon, Sr., for
introducing me to photography a long time ago; and Daniel, Judith, Kayla, and Robert
at photoworkshop.com for their friendship.

Special thanks goes to **Canon** for their support.